QE2
A Photographic Journey

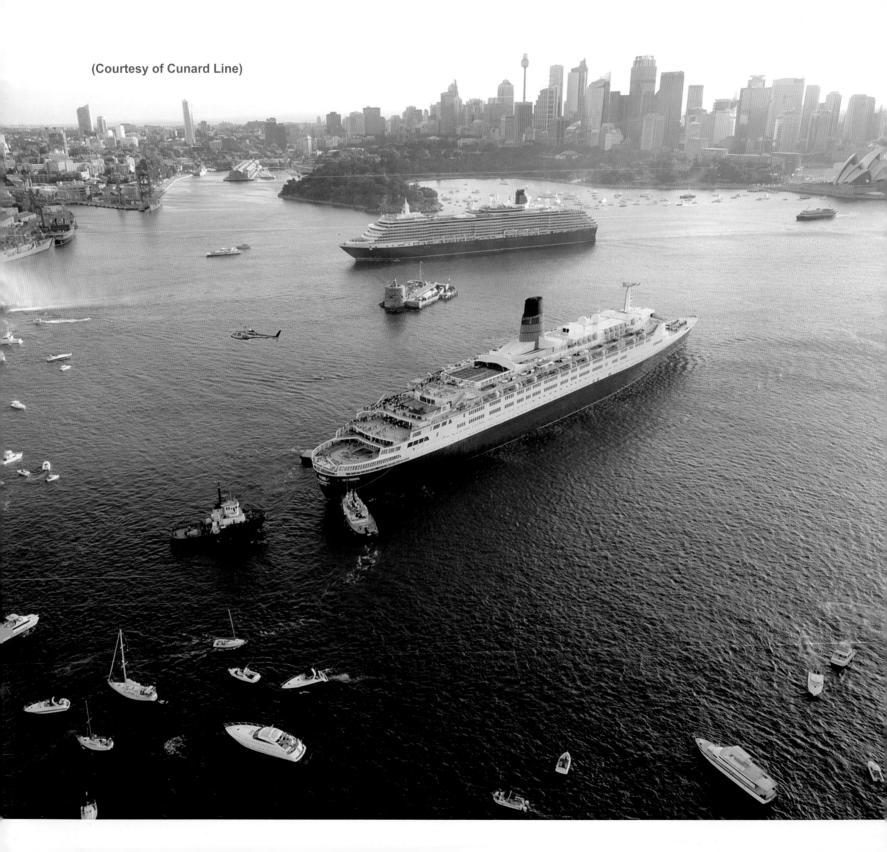

QE2

A Photographic Journey

CHRIS FRAME AND RACHELLE CROSS

FOREWORD BY WILLIAM H. MILLER JNR

WITH CONTRIBUTIONS FROM

COMMODORE RONALD W. WARWICK,

COMMODORE CHRISTOPHER RYND

AND CAPTAIN IAN MCNAUGHT

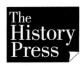

The History Press

For Neville & Elvie

First published 2008

This paperback edition 2013

The History Press

The Mill

Brimscombe Port

Stroud

Gloucestershire

GL5 2QG

www.thehistorypress.co.uk

British Library Cataloguing in Publication Data.
A catalogue record for this book is available from the British Library.

ISBN 978-0-7524-9150-9
Typesetting and origination by The History Press Ltd
Printed in India

CONTENTS

FOREWORD

BY WILLIAM H. MILLER JNR

Especially in recent years, but perhaps for a much longer time, there has been no more beloved and cherished ship, liner or otherwise, than the *Queen Elizabeth 2*. She is the longest-lasting super liner; the longest-serving Cunarder, having steamed more miles, carried more passengers, visited more ports, sailed on more itineraries. Back in 1969, when she was commissioned, Cunard could not have guessed that she would be so incredibly successful. She has legions of fans. There are travellers (and I've met some of them), who will sail on no other ship, except maybe the *Queen Mary 2*, her nearest relative. The *QE2*, as she is best known, is rich in charm. She's like, in her increasing old age, a venerable seaside hotel – warm, comforting, always welcoming. A friend once compared her to a good rocking chair. You just want to be there! Myself, I've made some thirty trips on her – and hope for more – including crossings, cruises, specialty trips such as the YPO (Young Presidents' Organisation) Charter Cruise in October 1990 and her 30th Anniversary Cruise in June 1999. I was aboard her then fleet mate, the *Vistafjord*, as we anchored across from the *Queen* during Cunard's 150th Anniversary Celebrations off Spithead in July 1990.

I was aboard a chartered excursion vessel, one that normally shuttled the likes of Midwestern tourists and school groups between Lower Manhattan and the ever popular Statue of Liberty in New York's Lower Bay. We met the *QE2* as she arrived for the first time on an otherwise grey May morning in 1969. At first sighting she was big, imposing, quite regal, certainly modern. But she was also quite different, almost radical with her single, pencil-like white funnel, the lack of traditional Cunard black and red-orange funnel colours and, in red lettering, the name Cunard written across her forward superstructure, as if she were some new, high-tech container ship or something.

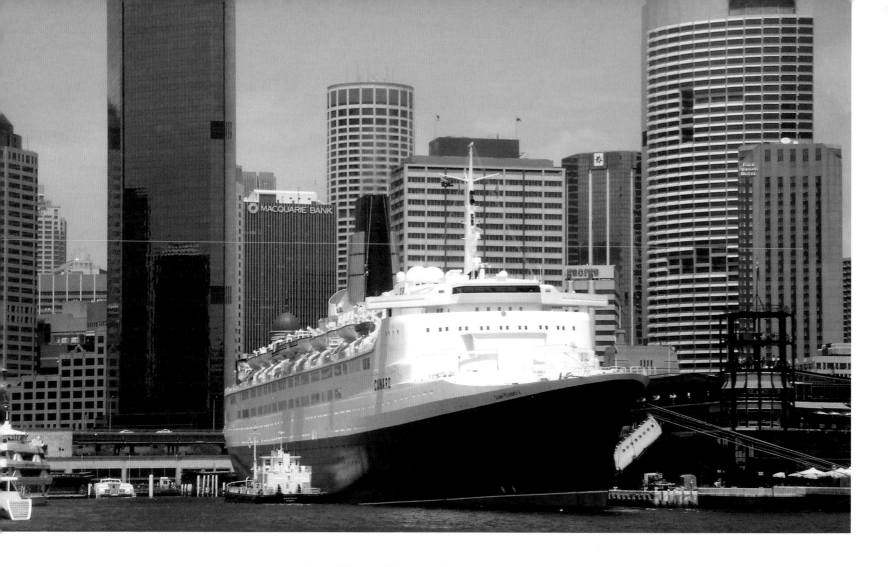

We studied her from every angle as she slowly, quite gracefully, made her way up along the Hudson to her West Side berth at West 52nd Street. Horns, whistles and sirens sounded in royal salute. But greater, more eye-opening impressions were to be made once we boarded. Indeed, as Cunard called her, she was 'the ship of tomorrow'. That circular entrance foyer hinted of *Star Wars*, for example, while the Queens Room had white scoop chairs and fluted Formica columns and then there was a circular glass and stainless steel stairway in the Double Down Room. Yes, she was different – but quickly became the hottest ticket in town.

Everyone, or so it seemed, wanted to sail on the *QE2*. I had my first trip in November 1970, flying to the Caribbean and then taking her northbound to New York. We were thrilled!

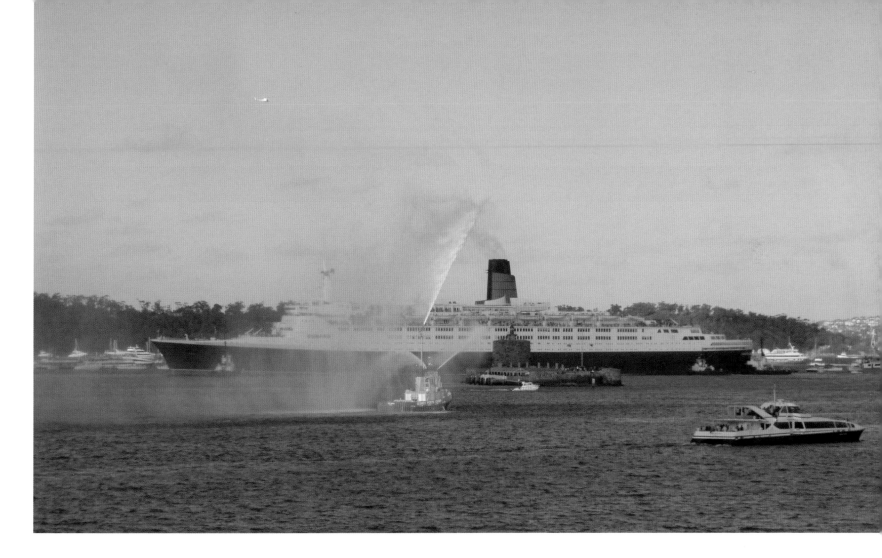

I met Chris Frame and Rachelle Cross on board the *Queen Mary 2*, during a celebratory voyage from San Francisco to Sydney. I was deeply impressed with their fascination, interest and high knowledge of this beloved Cunarder. Personally, I believe there can never, ever be enough books or other documentation or commemoration of the *QE2*. So, it is with the greatest pleasure that I offer this short foreword to a book of splendid photos; a photographic tour of one of the greatest liners, grandest Cunarders, one of my favourite liners of all.

So, the lines are being let go. The whistles are sounding. We are off on a literary voyage in this marvellous book. Three blasts for the *QE2*!

Bill Miller
New Jersey

ACKNOWLEDGEMENTS

We would like to thank everyone who helped us in our writing journey.

Special thanks to:

Bill Miller for his continual encouragement, writing the foreword and providing publication advice; **Commodore R.W. Warwick** for providing us with insight into the running of the ship from a captain's perspective, and for providing photographs; **Captain Ian McNaught** for organising the absolutely amazing tour '*QE2* Behind the Scenes' as well as his encouragement, enthusiasm and writing the afterword; **Commodore Rynd** for sharing his perspective of commanding *QE2*; **Chief Engineer Paul Yeoman** for taking us through the Engine Room; **Ed Stickley, Donyin Lin** and **Andrea Kaczmarek** for taking us 'behind the scenes' and **Gregory Dorothy** for the tour of the storerooms; **Thad Constantine, Michael Gallagher** of Cunard Line, **Jochen Gielen, Alex Lucas, Howard Massey, Pam Massey,** and **Leighton Schembri** for their photographic assistance; **Amy Rigg, Emily Locke, Christine McMorris, Glad Stockdale** and the team at The History Press for all their hard work; **Rob Lightbody** and the whole team at the QE2 Story Forum for keeping the legend alive; **Catherine van Niekerk** for providing inspiration; **Jan, John, Vicki** and our families for supporting us.

All photos, unless otherwise credited, were taken by Chris Frame or Rachelle Cross.

A ROYAL INTRODUCTION

For over forty years the *QE2* has been touching people's lives. She sailed more than 5.8 million miles, carrying nearly 3 million passengers in style, comfort and elegance.

Throughout these countless voyages millions of memories have been created. Some passengers remember a taste, perhaps one of the thousands of meals served every day. Others remember the feel of the ship as she gently rocks you to sleep on a calm summer night. For others it was the friends they met aboard, something funny they said or did in the Queens Room or Yacht Club.

No matter what the memory, it will undoubtedly be a special one, retold with enthusiasm and excitement as the past guest regales those back at home with their special experience aboard the one and only *QE2*.

She is unique in a world where conformity seems to rule the waves. *QE2*'s quirks delight and frustrate guests, with corridors and stairways that lead to nowhere and odd-shaped cabins on Four Deck and Five Deck.

These unique features of a true ocean liner are rare in today's world and should be cherished. In service with Cunard from 1969 to 2008, *QE2* was kept in good condition, evolving through various refurbishments to become a cosy and elegant English country house at sea.

This book has been created to give a lasting memory of Cunard's *QE2*, her rooms, decks, exterior profile, facts and amusing stories that you can cherish for a lifetime.

LOOKING BACK

U nlike Cunard ships of the past, *QE2*'s biggest rival was not another liner, but the jet aeroplane. Rather than purpose building her for the North Atlantic run alone, *QE2*'s design allowed for the flexibility of cruising. The last liner to be built on British soil, she was constructed by John Brown & Co., Clydebank (Scotland) and her keel was laid on 5 July 1965. In Cunard tradition, she was known only by her building number, 736.

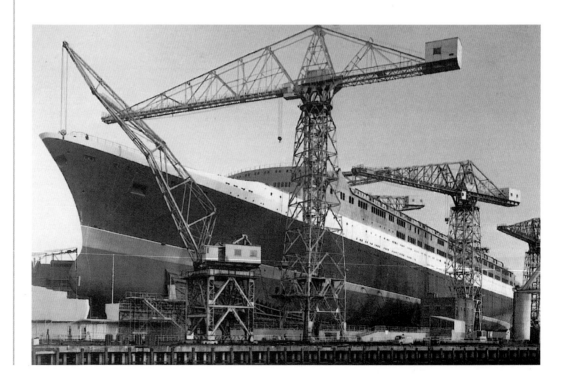

(Courtesy of Commodore R.W. Warwick, *QE2: The Cunard Line Flagship* Queen Elizabeth II)

Number 736 was christened on 20 September 1967 by the reigning monarch, Queen Elizabeth II. Cunard had agreed to name the ship *Queen Elizabeth* after the elder Cunard liner, which would be retired by the time the new ship entered service, however the Queen refused the envelope containing the ship's name and uttered the words, 'I name this ship Queen Elizabeth the Second'. To avoid confusion, Cunard opted to use the numeral '2' for their ship and *QE2* was born.

After extensive fitting out and trials, the ship was accepted by Cunard Line on 20 April 1969, some four months late. Her maiden voyage left Southampton on 2 May 1969 bound for New York.

Over nearly forty years of Cunard service, *QE2* has led an interesting and varied life. This started early in her career, when she was the first vessel to assist the stranded passengers of the burning French Liner *Antilles* in January 1971.

During a May crossing in 1972, *QE2*'s captain received notification that there was a bomb aboard his vessel and that it was timed to go off during the voyage. A search by crew members proved fruitless and a bomb disposal unit was flown out and parachuted into the sea close to the ship. The incident turned out to be a hoax but the FBI succeeded in arresting the culprit.

QE2's life changed dramatically in 1982 when the ship was requisitioned to serve as a troop carrier during the Falklands War. The ship's captain and officers heard this news on 3 May 1982 via BBC radio, before any official communication had been received from Cunard Line. Conversion work involved the addition of helicopter flight decks, which required cutting away the aft of Upper and Quarter Decks to provide the necessary space.

The ship set sail with the troops of the 5th Infantry Brigade aboard on 12 May 1982, arriving in the Falklands on 27 May. Due to the threat of Argentinean air reconnaissance she was kept in the relative safety of Cumberland Bay and, after taking aboard the survivors of HMS *Ardent*, *Antelope* and *Coventry*, sailed north towards safety.

During her military career *QE2* successfully sailed over 14,900 miles, consuming more than 10,200 tons of fuel to deliver 3,000 troops to the war zone. Upon her arrival home she was met by the Royal Yacht *Britannia* and a flotilla of smaller boats.

QE2 has undergone many refits over the years, one of the most distinctive being her post-war conversion after which she appeared, for a time, with a pebble-grey hull.

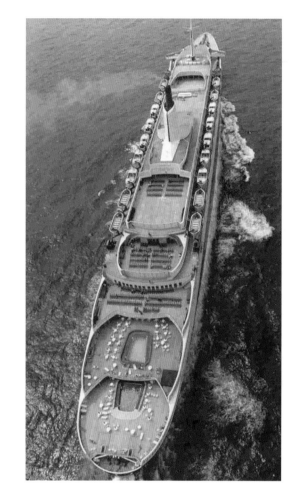

Aerial shot of *QE2* at sea in her original layout. (Courtesy of Commodore R.W. Warwick)

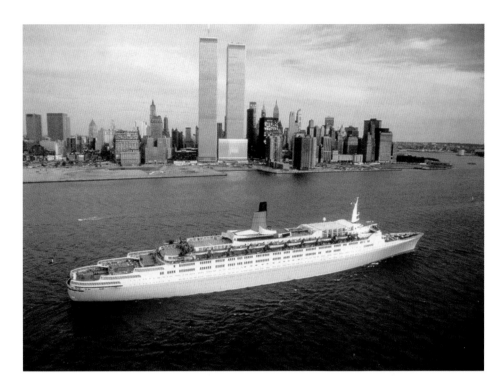

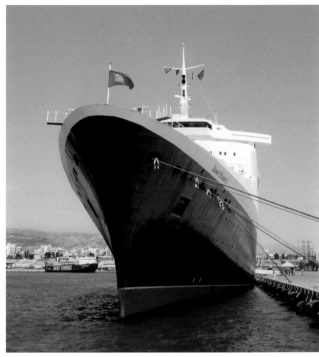

(Above left: Courtesy of Commodore R.W. Warwick, *QE2: The Cunard Line Flagship* Queen Elizabeth II)

DID YOU KNOW?

QE2's planned use in Dubai was derailed by the Global Financial Crisis; however, she was used as the venue for a lavish New Year's Eve Party in 2011/12.

Another of her major refits was the 1986/87 engine conversion. This involved removing the original steam turbine engines and replacing them with nine diesel–electric engines. This was, at the time, the largest maritime conversion ever undertaken.

In late 1994, *QE2* made headlines around the world when her one-month, $45 million internal and external refurbishment ran over schedule, resulting in the ship sailing with workers still aboard. The refit included the re-design of nearly every room aboard, creating a sense of continuity in the public rooms. Every cabin was refreshed and the bathrooms replaced with modern units including marble basins. This work was enhanced in more recent years with the 1999 refit which included a complete hull strip and re-paint, while the 2001 refit refined the classic interior which had been added during 1994, with the ship emerging as the *QE2* we see today.

In November 2008 *QE2* was retired from Cunard service. After an emotional farewell from the city of Southampton she set sail for Dubai where, on 27 November, she was officially handed over to her new owners.

WELCOME ABOARD

O n boarding the *QE2* you traditionally enter via the Midships Lobby. Located on Two Deck, amidships, the lobby is decorated with four murals painted by British artist Peter Sutton, which were added during the 1994 refit. The murals depict the Cunard story, beginning in 1840.

In chronological order, the first mural introduces the Cunard Line. It features Sir Samuel Cunard, the company's founder, and his first vessel, RMS *Britannia*. The company was originally funded by the British Government in return for providing a guaranteed regular mail service between Britain and the 'New World'. As such, passenger accommodation was spartan, with milk and eggs sourced from livestock carried aboard.

Mauretania graces the second mural. The *Mauretania* was famous for being the fastest ship on the North Atlantic for many years. She held the highly coveted Blue Riband from 1907 to 1929. There had been vast improvements in passenger accommodation by this time and First Class became comparable to the finest hotels on land.

Queen Elizabeth and *Queen Mary* are the focal point of the third mural. They achieved a long-held Cunard ambition to run a two-ship shuttle service between Britain and the US. These great liners were the largest ships to have worked the North Atlantic Passage, until the advent of *Queen Mary 2* in 2003. The mural pays homage to the service provided by both ships during the Second World War and celebrates their return to passenger service before their peak in popularity during the 1950s.

An icon amongst icons, the final mural is of *QE2* herself. She is seen with various world landmarks including the Twin Towers of New York and the Sydney Opera House. The mural celebrates the building and launch of *QE2*, the last Ocean Liner to be constructed on the Clyde.

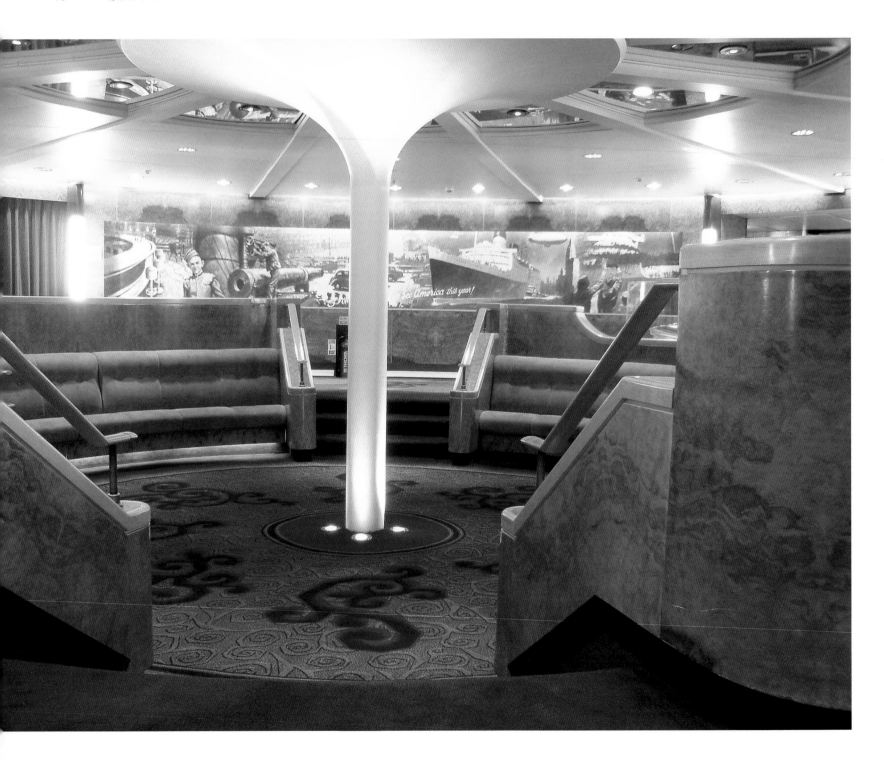

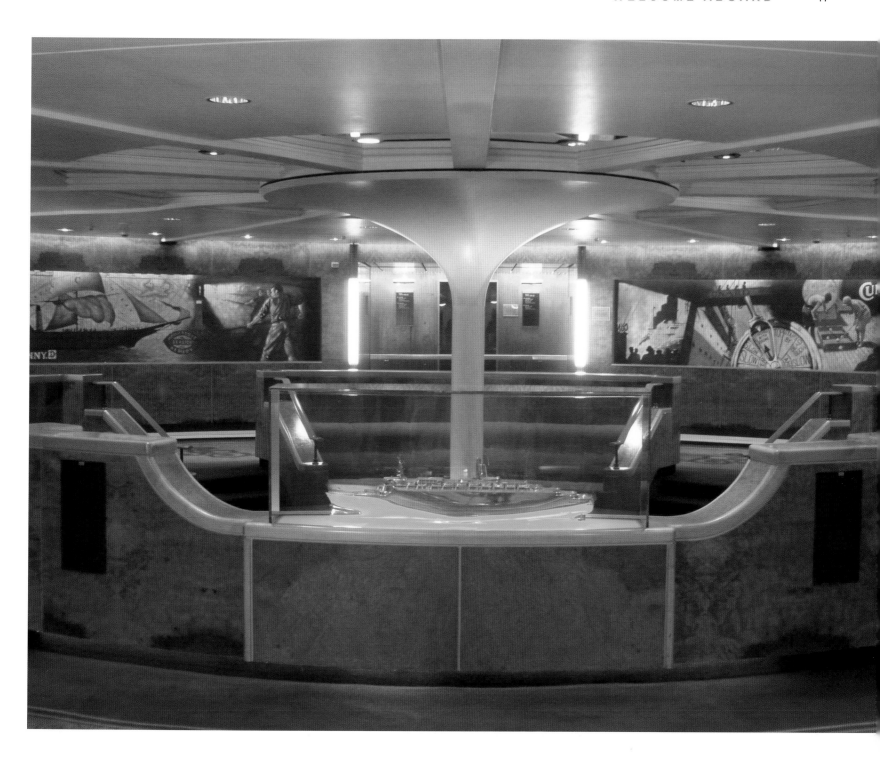

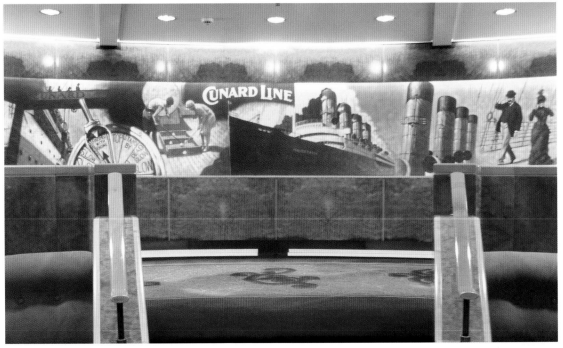

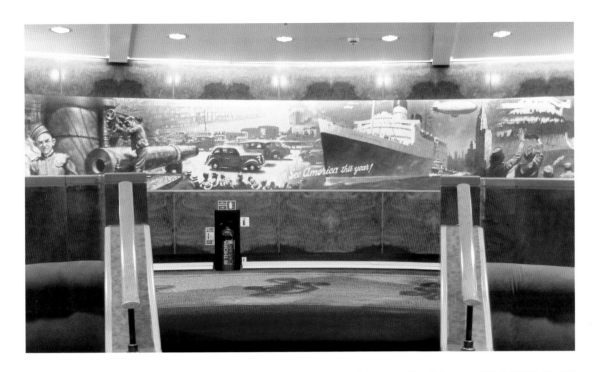

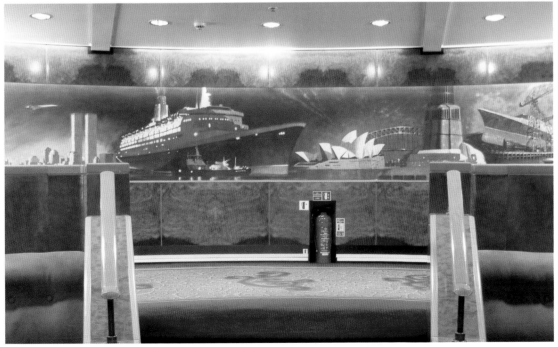

ACCOMMODATION ABOARD

(Courtesy of Howard Massey)

There are five different accommodation grades aboard the *QE2*. Each grade coincides with a different restaurant. Cabins range in size and luxury from the ultra deluxe Queen Elizabeth Suite, measuring an impressive 110 square metres, to more cosy interior cabins at a modest 8 square metres.

No matter what your budget, cabin stewards pride themselves on making your stay as enjoyable as possible. There is 24-hour room service in all levels of accommodation.

Rooms are serviced twice daily. Beds are turned down in the evening with Cunard branded chocolates left on the pillows. Some cabin stewards even get creative, folding towels into impressive figures or arranging teddy bears to personalise each experience.

CLASS CONFUSION

In early 1998 an octogenarian male passenger of modest means befriended a female passenger while on the trans-Panama segment of the ship's annual world cruise. The gentleman, after some time, became convinced that the lady was only interested in him for his money.

After that point the gentleman avoided his one-time friend at all costs – even attempting to duck into the service areas of the ship if he saw her down the corridor. Several days later the lady approached the gentleman's son and asked why she was being avoided. Only then did it become known that while the gentleman was travelling on his modest budget in an inside cabin on Three Deck, the lady was occupying a suite on Signal Deck complete with balcony and butler.

GRILL CLASS ACCOMMODATION

Passengers who select Grill Class accommodation will find themselves in some of the most luxurious cabins at sea. *QE2*'s Grill Class spans six decks and encompasses Queens Grill, The Princess Grill and The Britannia Grill grades.

The most prestigious addresses aboard *QE2* are suites on Signal and Sun Deck, which are off-limits to other passengers and accessed via the Queens Grill Lounge. Signal and Sun Deck are distinctly different from the rest of the ship in layout and décor.

The suites on Signal and Sun Deck have balconies which makes them unique among cabins aboard. They also have a butler service in addition to the regular cabin steward.

Passengers in Grill Class on Boat Deck, One, Two and Three Decks will enjoy spacious cabins with walk-in wardrobes, a lounge area, multiple portholes and a full-sized bath as well as a shower.

While these cabins may be smaller than those on Signal and Sun Deck, they have the bonus of being within the ship's hull and thus there are no obstructions to the view.

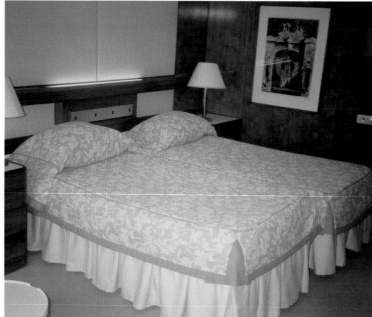

CARONIA ACCOMMODATION

S till considered 'First Class' but without the price tag associated with the Grill Class experience, Caronia cabins span from One Deck to Four Deck.

This level of accommodation offers relatively spacious cabins with one or two portholes, a television and an en-suite bathroom. Some cabins have full-size baths, while others have showers only.

Caronia accommodation offers single cabins on various decks for the solo traveller. Passengers in this level of accommodation will enjoy fine dining in the Caronia Restaurant.

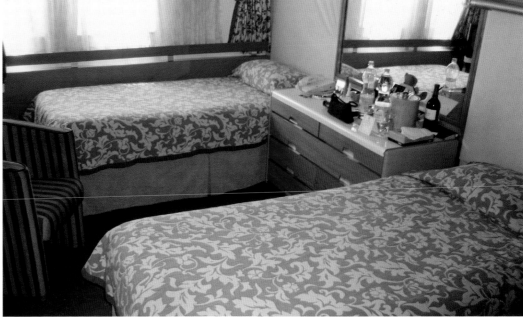

MAURETANIA ACCOMMODATION

The most affordable level of luxury aboard *QE2* is found in the Mauretania grade cabins. These rooms are modest in comparison to the Grill Class, yet comfortable, with ample closet space and an en-suite bathroom with shower.

Mauretania cabins come in seven different price categories and can be inside, or ocean view with one porthole. Due to the ship's unique design as a transatlantic liner, these cabins are all very different in their layout, thus it is difficult to find two cabins with the same configuration.

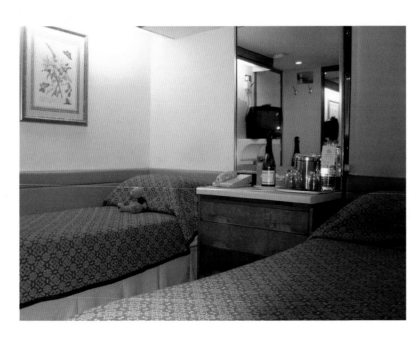
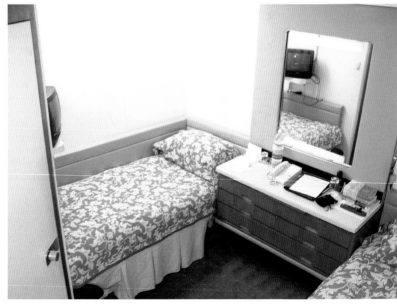

RESTAURANTS

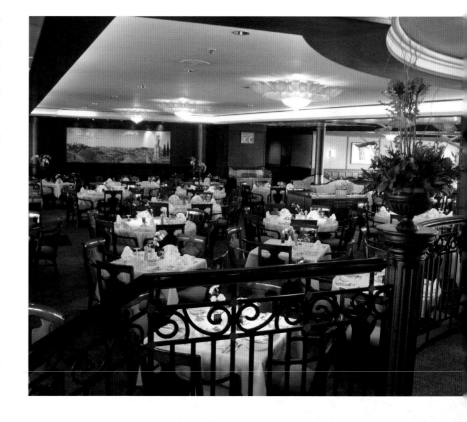

Dining aboard *QE2* is one of the finest culinary experiences at sea. The ship has seven restaurants ranging from the intimate Grills to a self-service buffet and pool-side eatery. While each restaurant presents passengers with a different menu every night, *QE2*'s Queens Grill restaurant is widely known for being able to offer its guests meals that are not specified on the menu.

RESTAURANT PROFILE

Restaurant	Location	Seatings	Rating
Queens Grill	Boat Deck	Single Seating	4 ½–5 star
Princess Grill	Quarter Deck	Single Seating	4–5 star
Britannia Grill	Quarter Deck	Single Seating	4–5 star
Caronia Restaurant	Quarter Deck	Single Seating	4 ½ star
Mauretania Restaurant	Upper Deck	Double Seating	3 ½– 4 star
The Lido	Quarter Deck	Open Buffet	Alfresco
The Pavilion	One Deck	Open Grill	Alfresco

Heard at dinner, 1,000 miles from land:
'Do the crew sleep on board?'

QUEENS GRILL

The Queens Grill was added during the ship's 1972 refurbishment to accommodate the newly created balcony accommodation on Signal and Sun Deck. The restaurant is widely thought of as one of the finest at sea.

As a Cunarder, *QE2*'s Queens Grill was one of the largest consumers of Beluga Caviar in the world (second only to the Russian Parliament).

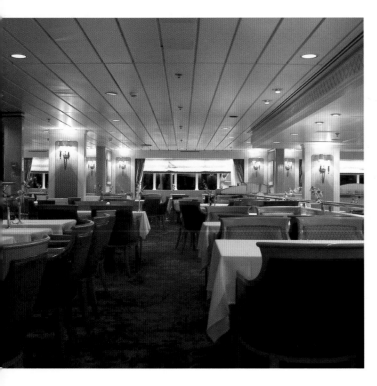

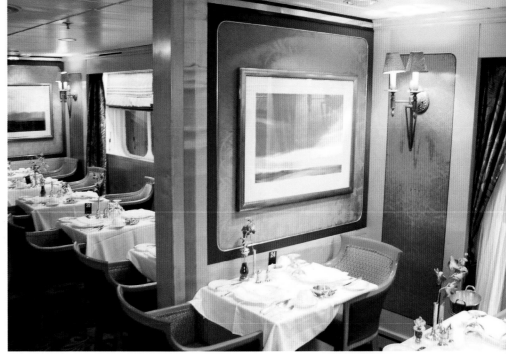

Luxuries in the Queens Grill include silver service from the most experienced waiters onboard. Chafing-dishes are often used in this restaurant with guests enjoying the chance to watch their meals come together before their eyes. Passengers dining in this restaurant will have paid the highest tariff for their voyage and will enjoy Q grade accommodation.

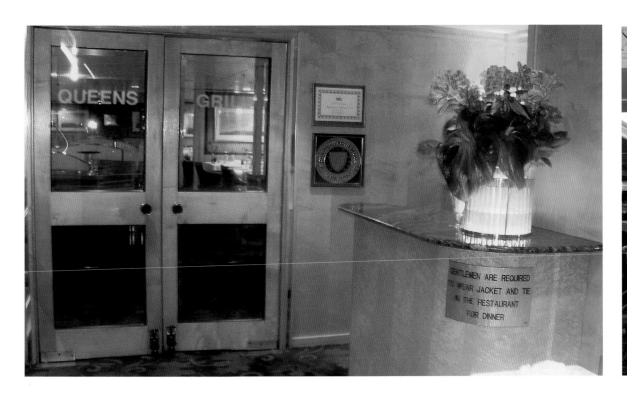

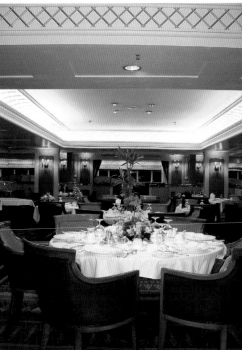

THE PRINCESS GRILL

O riginally named 'The Grill Room', this restaurant catered for the passengers occupying premium cabins on One Deck and Two Deck. The focal points of this room are four statues by Janine Janet, which represent the four elements. They are made entirely from marine objects, including shells and mother-of-pearl.

During the 1972 refurbishment, when the Queens Grill was created, The Grill Room was renamed Princess Grill. As part of the 1990 refurbishment, a new restaurant was created on

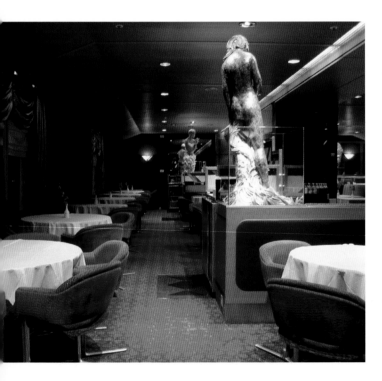 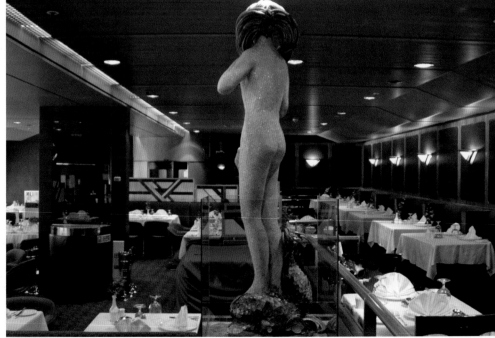

the Starboard side and was named Princess Grill Starboard. To differentiate between the two, the original Princess Grill was known as the Princess Grill Port.

The Princess Grill is one of the least modified rooms on the ship, having retained much of its original charm since the first passengers dined there in 1969.

In late 1994 the word 'Port' was dropped from the name and the restaurant became The Princess Grill.

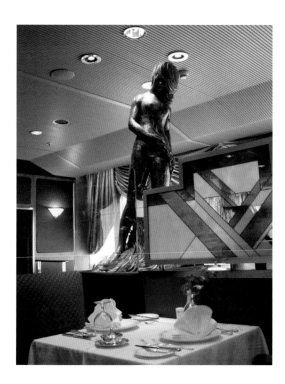

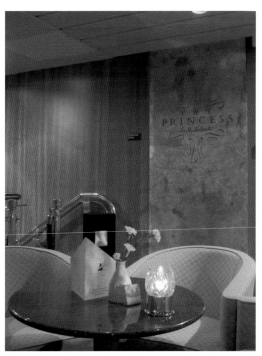

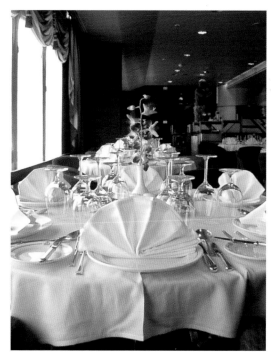

THE BRITANNIA GRILL

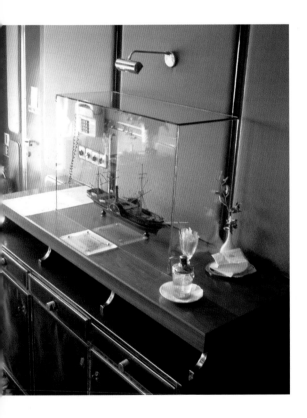

Passengers dining in the Britannia Grill access the restaurant through the Crystal Bar on Upper Deck. Descending a private staircase to Quarter Deck, passengers are welcomed by a model of the *Britannia* of 1840 (Cunard's first ship). The Britannia Grill (originally known as Princess Grill Starboard) was created during the 1990 refurbishment. The area was previously part of the Columbia Restaurant (now called Caronia).

The Britannia Grill has a more subtle appearance than the Princess Grill and thus is favoured by many repeat guests.

A popular story told aboard *QE2* took place in the mid-1990s when a passenger asked the waiter if he was able to order anything he wanted. 'Of course you can sir,' replied the waiter. The passenger then ordered an elephant ear in a bun, to which the waiter replied: 'Will that be African or Indian, sir?'

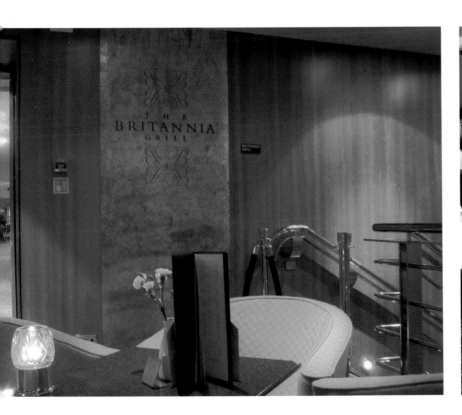

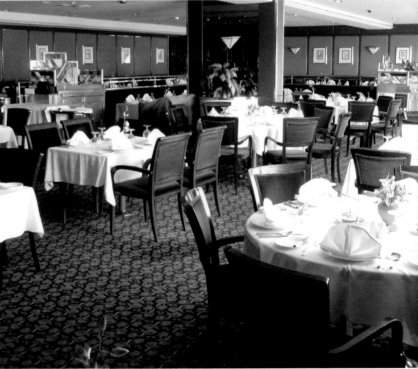

CARONIA RESTAURANT

L ocated on Quarter Deck, the Caronia Restaurant caters for 538 people a night. The restaurant, originally named Columbia, underwent a major redesign during the vessel's 1994 refurbishment, emerging as the new Mauretania Restaurant. This change was short-lived with the room reverting to service Columbia passengers in 1997, although it was now named Caronia.

During the 1999 refurbishment at Lloyd Werft in Bremerhaven in Germany, the room was redesigned again, this time in an 'old world' elegant style reminiscent of the great ocean liners of the 1920s. This room is one of the most beautiful aboard *QE2* and attracts many repeat guests.

DID YOU KNOW?

A person would have to eat two packets of cereal every day for more than a year to equal the consumption of cereal aboard the *QE2* in one day!

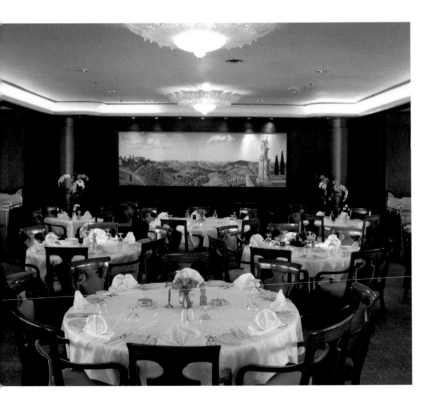

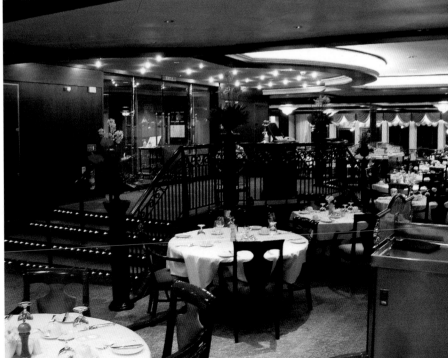

MAURETANIA RESTAURANT

The Mauretania Restaurant owes its name to the Cunard liner of 1907. Both were named for the Ancient Roman province, and not the African nation of Mauritania.

A statue of four horses, depicting 'White Horses of the Atlantic Ocean', is the centrepiece of this room and represents the water breaking on the bow of the ship.

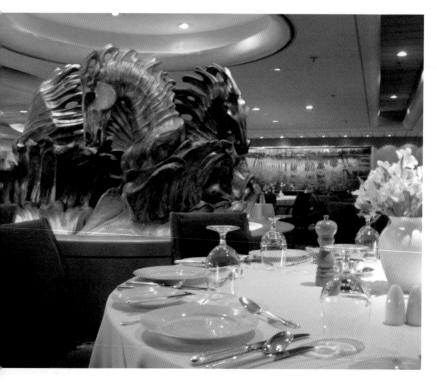
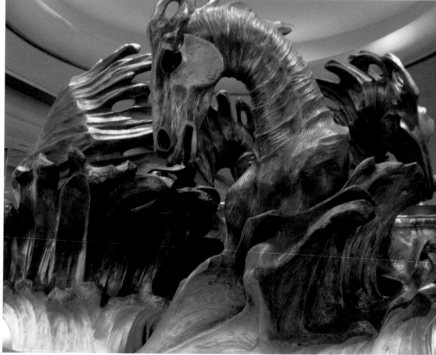

This incarnation of the Mauretania Restaurant came about during the 1994 refit, when it also became known as the Caronia. Due to popular demand the restaurants reverted to their original locations in 1997, but the décor remained unchanged.

The Mauretania Restaurant caters to a double seating arrangement (one at 6.00 p.m. and the other at 8.30 p.m.), the only restaurant aboard *QE2* to do so.

DID YOU KNOW?

The Mauretania Restaurant is the most re-named major public room aboard. It has been known as Britannia Restaurant, Tables of the World, Mauretania, and had a short-lived stint as the Caronia Restaurant.

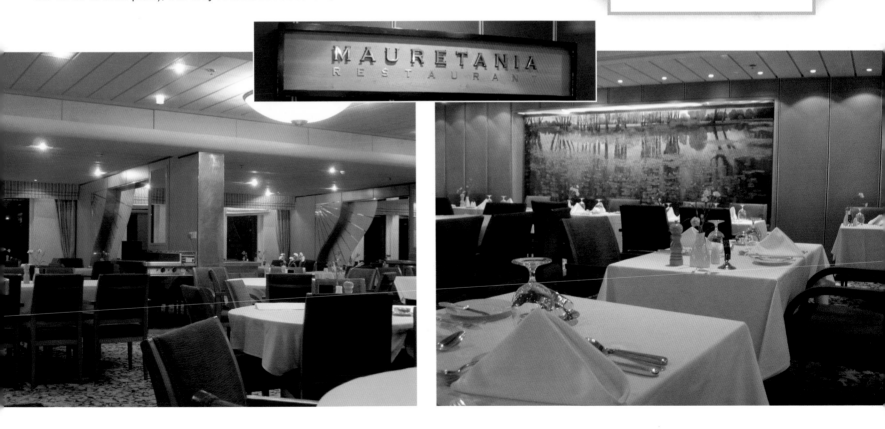

THE LIDO

The Lido is the *QE2*'s Buffet Restaurant. It is open almost 24 hours a day, serving breakfast, lunch, afternoon tea, dinner and the popular midnight buffet.

The area was originally an open deck with an outdoor swimming pool. In November 1983 this space was enclosed under a Magrodome – a glass roof that can be opened during good weather. This proved impractical as the roof was often closed and caused a greenhouse effect.

Below: The Lido with open Magrodome.
(Courtesy of Commodore R.W. Warwick)

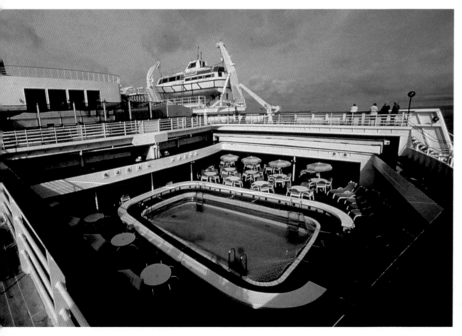

The decision was made during the 1994 refit to remove the Magrodome and fully enclose the Lido. The swimming pool was also removed as it was underutilised, with most passengers preferring to swim in the One Deck pool.

These changes allowed for an enhanced buffet service, complemented by the Lido Bar for dinner drinks.

Today's Lido has a Winter Garden theme and is a popular alternate dining venue.

DID YOU KNOW?

It was estimated in 1994 that the *QE2*'s kitchens crack more than 3 million eggs per annum.

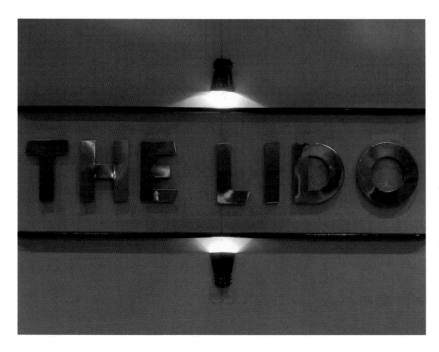

MIDNIGHT BUFFET

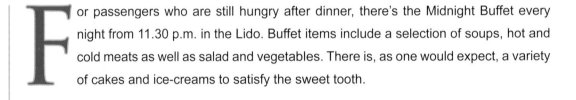

For passengers who are still hungry after dinner, there's the Midnight Buffet every night from 11.30 p.m. in the Lido. Buffet items include a selection of soups, hot and cold meats as well as salad and vegetables. There is, as one would expect, a variety of cakes and ice-creams to satisfy the sweet tooth.

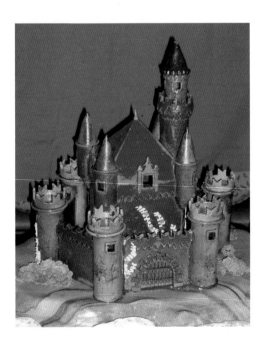

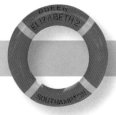

An event on most cruises is the Gala Midnight Buffet, where the chefs dazzle passengers with culinary art, creating masterpieces of gastronomic delight. Some star attractions include a Chocolate Castle and Penguin Island as well as fruit animals. However, visual beauty aside, some would argue that the best part of the buffet is that most items are edible!

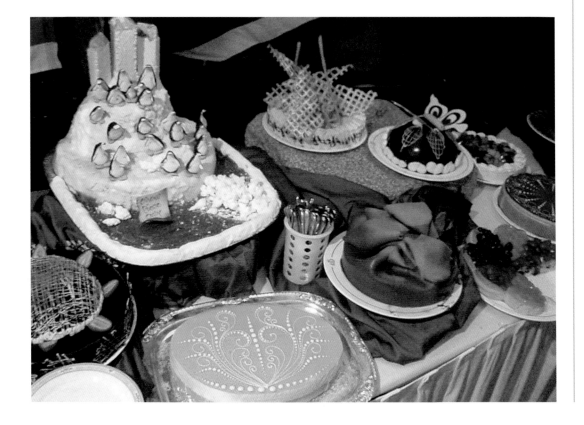

THE PAVILION

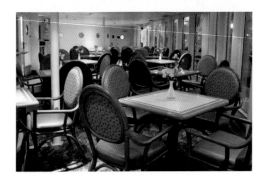

The Pavilion was added in 1994 and serves as an informal eatery. It is located near the One Deck pool and can be accessed by twin staircases descending from the Lido.

This restaurant is popular for its burgers, hot dogs and sandwiches made to order, as well as a range of pizzas and desserts. There is also a soft-serve ice-cream machine which is in constant use during the day.

The Pavilion is the first restaurant to open in the morning, catering to the early risers. Its location near the outdoor pool makes it very popular with sunbathers who feel like a snack during the day.

PAVILION PONDERINGS

While on a rough crossing, a passenger observed that the water in the pool was quite choppy and asked a Pavilion chef, 'Is the water in the pool fresh water or from the sea?'

'It's sea water,' was the reply. The passenger directed another glance to the pool: 'Oh, well I guess that explains why it's so rough.'

BARS AND LOUNGES

If you fancy a drink on the *QE2* there is plenty of choice. There are twelve bars and lounges aboard serving everything from a draught pint in the traditional English pub, to a fruity cocktail by the pool, to the finest glass of bubbly in the champagne bar.

The *QE2*'s wine cellar is one of the best at sea, with vintages dating back to before the ship was put into service.

There is live entertainment every night including bands, pianists, harpists, production shows and karaoke. If you're in the mood to dance they can accommodate you in the nightclub or with ballroom dancing in the Queens Room.

BAR AND LOUNGE PROFILE

Bars and Lounges	Location
Funnel Bar	Sun Deck
Queens Grill Lounge	Boat Deck
Crystal Bar	Upper Deck
Golden Lion Pub	Upper Deck
The Casino	Upper Deck
The Grand Lounge	Upper Deck
Yacht Club	Upper Deck
The Chart Room	Quarter Deck
The Queens Room	Quarter Deck
Lido Bar	Quarter Deck
Princess Grill Lounge	One Deck
Pavilion Bar	One Deck

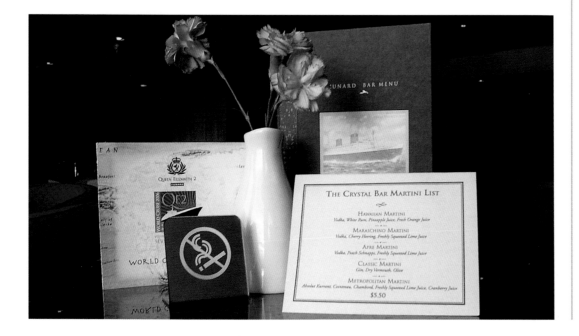

FUNNEL BAR

The Funnel Bar was added to *QE2* during her 2004 refit at Lloyd Werft in Bremerhaven. The area had previously been an underutilised sunbathing deck.

The Funnel Bar has proven a popular addition to the ship, serving a variety of bottled and draught beers, wine and cocktails. Passengers can relax on the

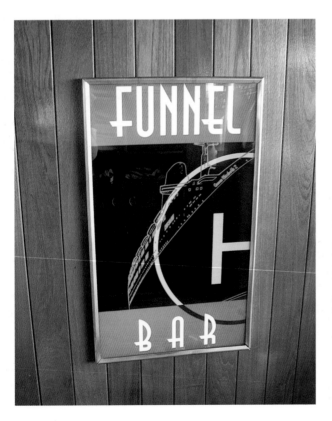

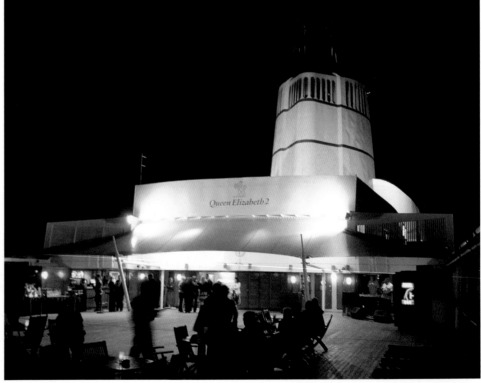

teakwood chairs provided or take their drink to other on-deck locations. This is the only true outdoor bar aboard *QE2*. Its location on Sun Deck provides a panoramic view which adds to the area's popularity. During 'sailaways' the Caribbean band plays on the open deck, creating a party atmosphere, with passengers dancing to the tunes.

Below right: (Courtesy of Leighton Schembri)

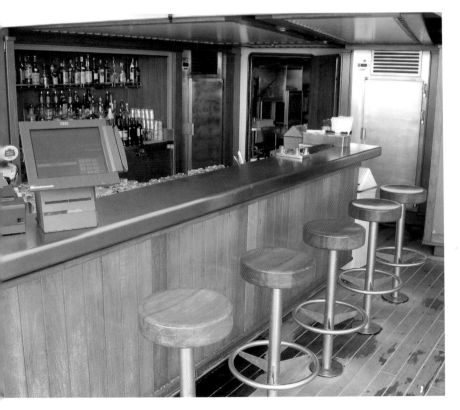

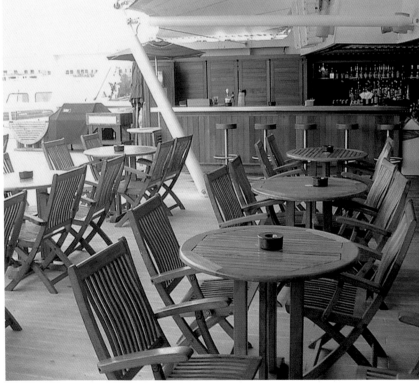

QUEENS GRILL LOUNGE

Passengers occupying Grill Class accommodation are welcome to relax and luxuriate in the private Queens Grill Lounge. The room serves as a lounge by day and a bar at night. Grill Class passengers can also partake of high tea in this lounge, served at 4 p.m. daily.

This room was originally designated as a bowling alley, until the practicality of such an activity on a moving vessel was considered. When *QE2* entered service the area was a 24-hour café and teenage lounge room. During the 1972 refit the area was converted into the Queens Grill Lounge and remains one of the most exclusive lounges afloat.

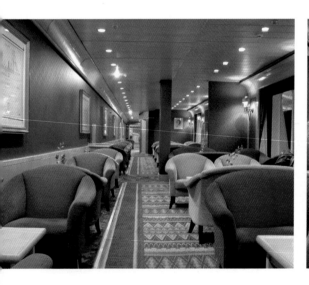
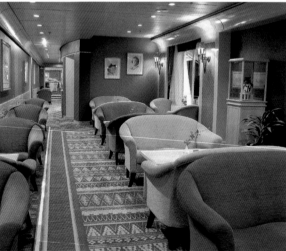
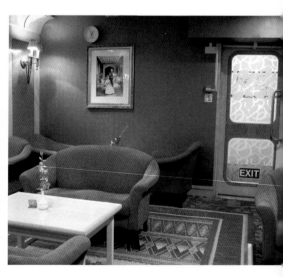

THE BOARDROOM

Relaxed and elegant with a décor that echoes that of the great ocean liners of days gone by, the Boardroom has become a popular room for the exclusive use of *QE2*'s VIPs.

During her annual world cruise, the Boardroom is converted into an elite concierge club for passengers taking the entire circumnavigation aboard the ship.

Cocktail parties and other private functions are also held in this room, which is located on the forward end of Boat Deck, on the Port side.

DID YOU KNOW?

In the 1993 episode of *Keeping up Appearances* entitled 'Sea Fever', Hyacinth Bucket attempts to 'crash' a private cocktail party held in the Boardroom by Commodore John Burton-Hall. It doesn't take the crew long to notice she's not an invited guest as she is wearing a jogging outfit at the time!

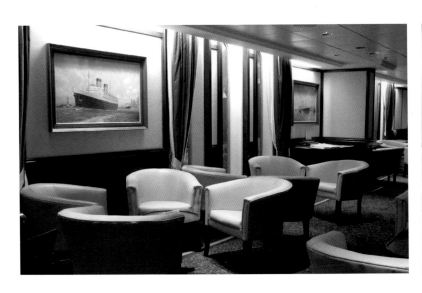
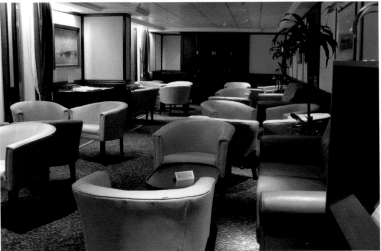

CRYSTAL BAR

The delightfully comfortable Crystal Bar can be found at the forward end of Upper Deck. This room, inspired by a bar aboard the original *Queen Elizabeth*, was created during the ship's 1994 refurbishment and was enhanced during the 1999 refit with new furnishings sporting deeper nautical colours.

The Crystal Bar was designed to serve passengers dining in the Princess Grill and the Britannia Grill, as well as the Mauretania Restaurant.

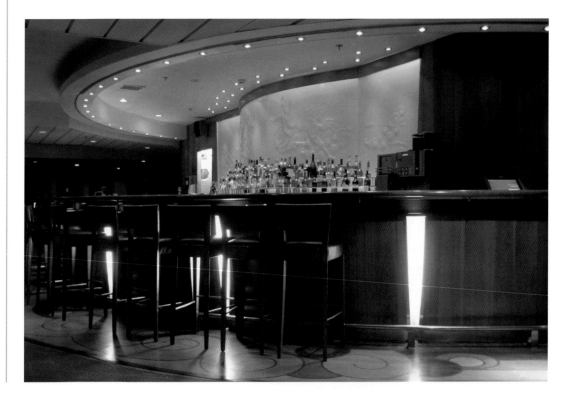

All three of these restaurants have entrances leading from this bar. During the day, passengers can enjoy bridge lessons hosted by the ship's cruise staff, while others prefer to play each other in a quiet game of chess or dominoes. Espresso coffee is available throughout the day creating a delicious aroma that complements the atmosphere of the bar.

DID YOU KNOW?

QE2 called at Southampton 726 times.

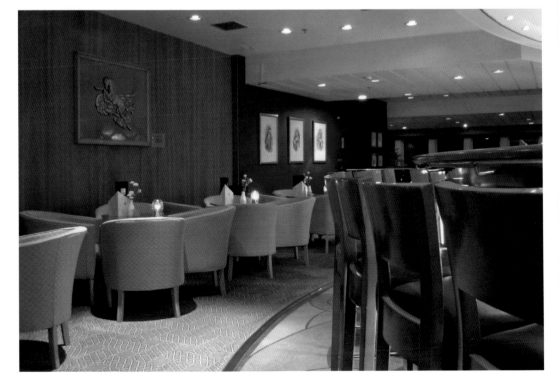

Below: The predecessor to the Crystal Bar, the Lookout Bar (Courtesy of Commodore R.W. Warwick)

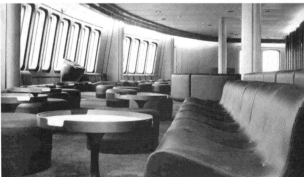

GOLDEN LION PUB

If you fancy a pint of Bass, Guinness or Becks the Golden Lion Pub is the place for you. It's a traditional English pub and in addition to having the finest beers and ales (on tap!) it also offers solid English fare such as fish and chips, bangers and mash and meat pie with mushy peas.

For those whose palate is a little bit more international, the Golden Lion Pub also has a wide range of spirits and wines.

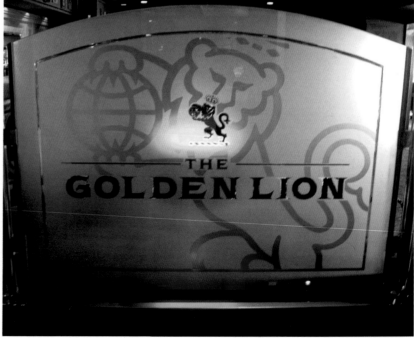

The room houses plaques presented to the ship on her maiden arrival in each new port. Jazz bands and pianists entertain gatherers during the afternoon and many passengers brush up on their card-playing skills over a quiet drink.

Braver passengers will enjoy entertaining their fellow guests with karaoke after dinner, while others prefer to watch live soccer matches on the plasma screens around the room.

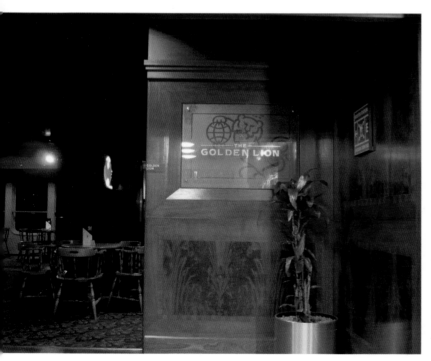

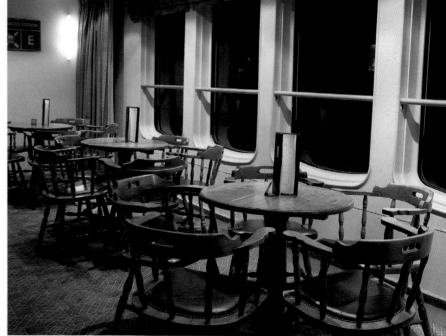

THE CASINO

For those passengers wishing to test their luck, the Casino is the place to go. The Casino is located in the middle of Upper Deck, just aft of the Theatre. It offers a wide range of games including blackjack, roulette, craps, poker and slot machines.

This space was originally the Upper Deck library but became the Players Club Casino in 1972. Since then it has undergone various refurbishments, bringing it up to date with the best casinos on land.

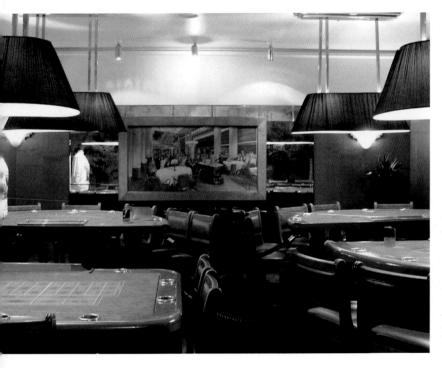
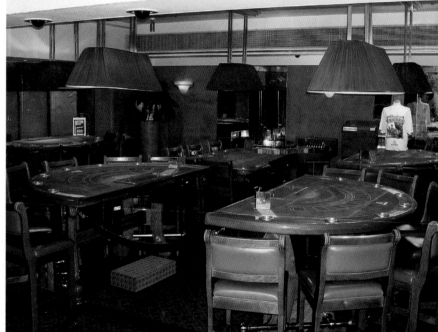

Drinks and snacks are provided by the Casino Bar, which is decorated with murals of life aboard the *Queen Mary* of 1936.

Due to maritime regulations the world over, casinos aboard ships are not permitted to open during time in port. However, there are always committed players who are waiting at their favourite slot machine while the ship heads out to open sea.

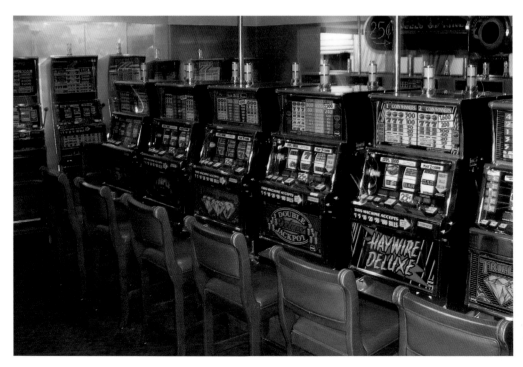

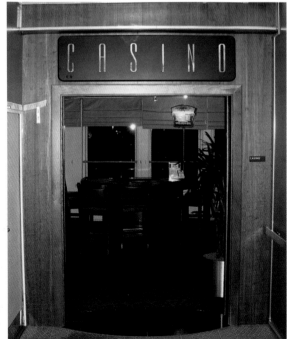

THE GRAND LOUNGE

Below left: This photograph depicts the Grand Lounge when it was the 'Double Down' room. (Courtesy of Commodore R.W. Warwick)

Below right: This photograph is taken from the same angle and shows the room as it is today.

The Grand Lounge is the largest room aboard *QE2*. It spans the width of the ship and is two decks tall.

Bingo is a popular daytime activity in the Grand Lounge. This is also the venue for some of the lectures given, including cooking demonstrations held by the head chefs from the various restaurants aboard.

The Grand Lounge was originally named the Double Down Room, but this was changed during 1987 when the 'International Shopping Concourse' (now the Royal Promenade) was added to the Boat Deck level.

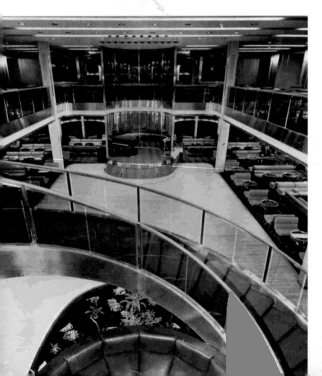

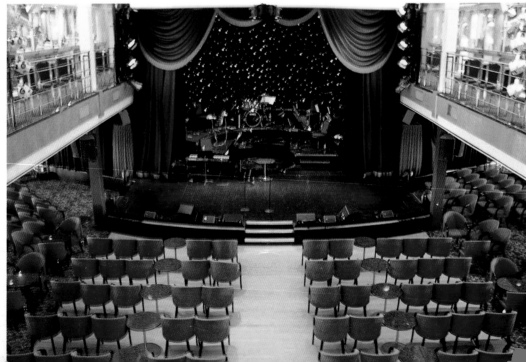

At night this room becomes the *QE2*'s show lounge, with full-scale production shows, comedy routines, magicians and musical performances as some of the highlights.

A passenger that many would remember occupied two suites on Signal Deck during the 1995 world cruise. One was for herself while the other accommodated her extensive soft toy collection. She was rarely seen about the ship during the day, however every evening just prior to the commencement of the show she would enter the Grand Lounge in a brilliant gown, escorted by one of her soft toys. Her favoured toy was a large golden teddy which earned her the nickname 'the lady with the golden bear'.

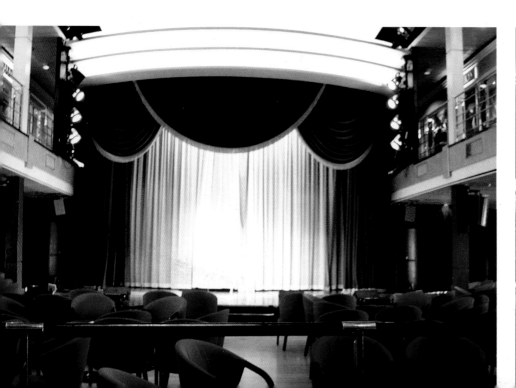

YACHT CLUB

By day a quiet lounge and bar with ocean views, the Yacht Club transforms every evening into the ship's nightclub.

Language classes are a popular afternoon pastime in the Yacht Club though others prefer to order a drink and check their e-mail courtesy of the WiFi access that is available in this bar. In the evening, music is provided by the ship's Caribbean band

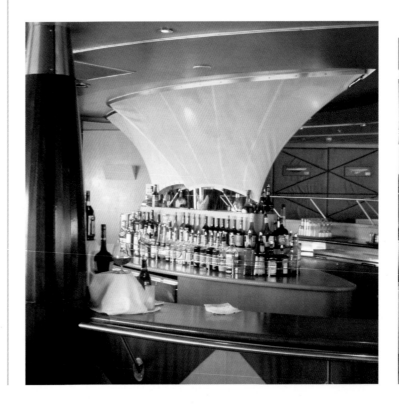

and energetic guests can dance the night away (the band will keep playing until the last passenger leaves the dance floor).

This room is decorated with memorabilia from yachts that have competed in the Americas Cup. Cocktails are the preferred drink in the Yacht Club and the bar has an impressive range of spirits and mixers.

DID YOU KNOW?

The teakwood deck aft of the Yacht Club replaced the Magrodome during the 1994 refit. This became the location for sail-away parties before the addition of the Funnel Bar.

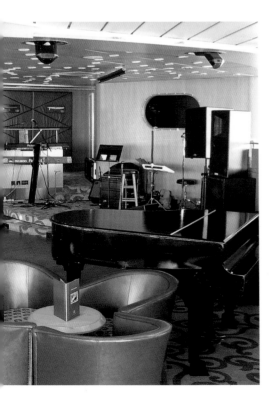

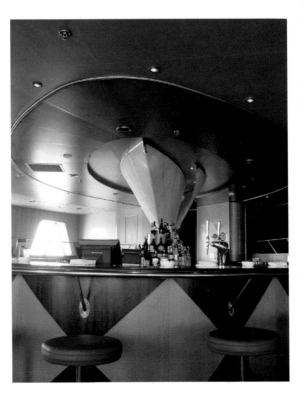

THE CHART ROOM

The Chart Room is situated on Quarter Deck near the Caronia Restaurant. As its name suggests, the Chart Room is decorated with nautical charts and traditional maritime navigational equipment.

Booklovers will enjoy the quiet lounge atmosphere of this room throughout the day, whilst puzzle fanatics can get their fix by helping with the giant jigsaws that are found at the forward end of this room.

By night, the Chart Room caters to patrons of the Caronia Restaurant, serving pre- and post-dinner drinks.

A baby grand piano, an original from the *Queen Mary* of 1936, is a key focal point of this room.

DID YOU KNOW?

QE2 carries 203 different kinds of wine, 171 different spirits and liqueurs and 37 champagne labels.

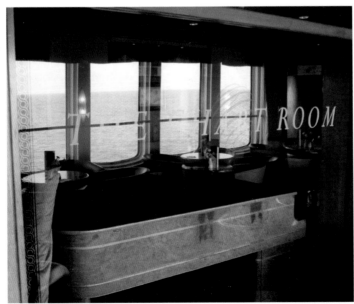
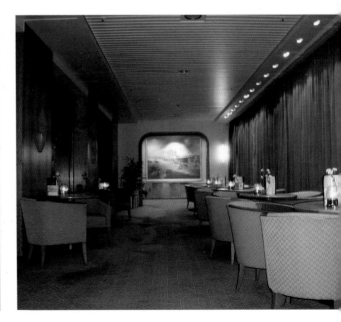

QUEENS ROOM

D ance classes, high tea and art auctions are the norm in the Queens Room. This lounge is *QE2*'s ballroom and stretches the entire 105ft width of the ship. It boasts a large wooden dance floor, mood lighting and an orchestra stage for live music performances. Regular themed balls are held during world cruises.

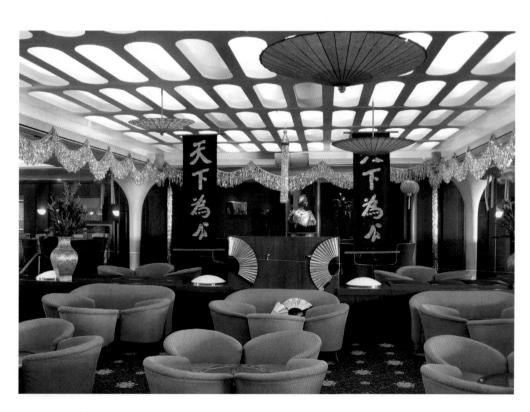

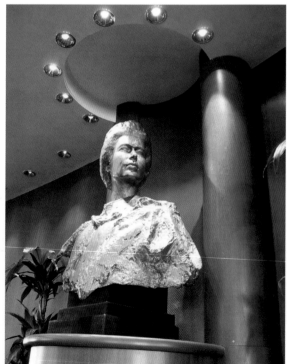

The room is named after Queen Elizabeth II who launched *QE2* in 1967, and a gold-leaf bust of the Queen is the centrepiece of the room.

Notable people who have graced this room include the Queen, Nelson Mandela and the late Princess Diana.

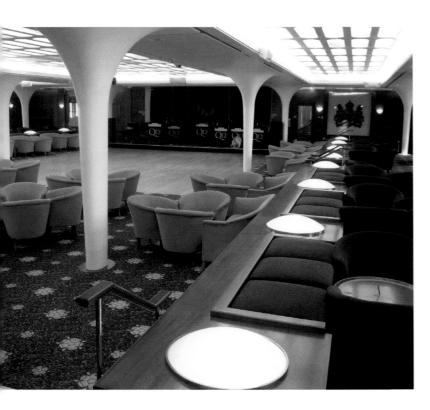

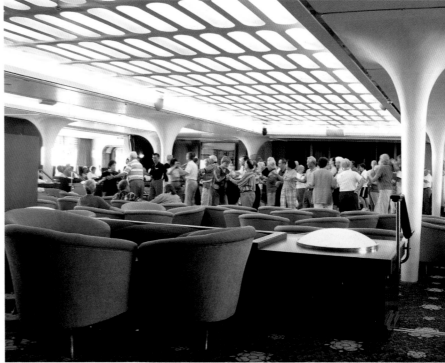

PRINCESS GRILL LOUNGE

Originally called the Grill Room Bar, this lounge once served pre-dinner drinks exclusively to the Princess Grill passengers. During the 1994 refurbishment, when the Crystal Bar was created on Upper Deck, this bar became the ship's champagne lounge. It still offers direct access to the Princess Grill via a spiral staircase or lift, however all passengers are now welcome.

It is interesting to note that since the 1994 refurbishment this bar no longer appeared on the brochure deck plans. This has resulted in a somewhat exclusive clientele of repeat guests and the inquisitive.

This lounge is located in the forward end of One Deck, near what was once the highest level of accommodation aboard.

A POPULAR CHAMPAGNE COCKTAIL: KIR ROYALE

Pour chilled champagne into a large wine glass;

Add ½oz of crème de cassis;

Stir gently;

You may wish to garnish with a twist of lemon rind.

PUBLIC AREAS

Aside from the restaurants and bars there are many other areas on *QE2* for passengers to enjoy.

Fancy a movie? Then head to the Theatre. Looking for a bit of R&R? Try the Royal Cunard Spa. For the fitness fanatic there's the gym and pool on Seven Deck while others may prefer to get their workout by shopping at the Royal Promenade.

Passengers can send and receive e-mails at the Computer Learning Centre on Two Deck. Regular classes are held here during the voyage to help even the most computer illiterate to master the basics. There is a vast collection of ocean liner memorabilia aboard *QE2* including paintings, models and Cunard artefacts. These were added during the 1994 refurbishment and are scattered about the ship, forming the 'Heritage Trail' (see Glossary).

SPECIAL AREAS OF INTEREST INCLUDE:

Name	Location
Royal Promenade Shops	Boat Deck
Theatre	Boat Deck / Upper Deck
Library & Bookshop	Quarter Deck
Giant Jigsaw Puzzle	Quarter Deck
Purser's Office	Two Deck
Computer Learning Centre	Two Deck
Synagogue	Three Deck
Royal Cunard Spa	Six Deck
Seven Deck Pool and Gymnasium	Seven Deck
Model Ships and Memorabilia	Everywhere!

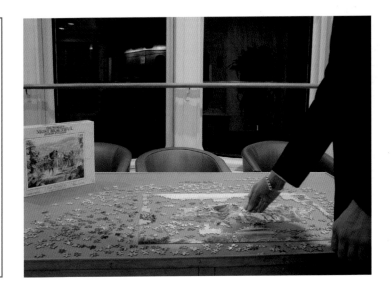

ROYAL PROMENADE

I f you desire duty-free jewellery, perfume, designer clothes or alcohol you'll find yourself visiting the Royal Promenade. Situated on the aft end of Boat Deck, the Royal Promenade overlooks the Grand Lounge and is open from early 'till late on sea days. *QE2* boasts the first Harrods at sea, and this is also located within the Royal Promenade.

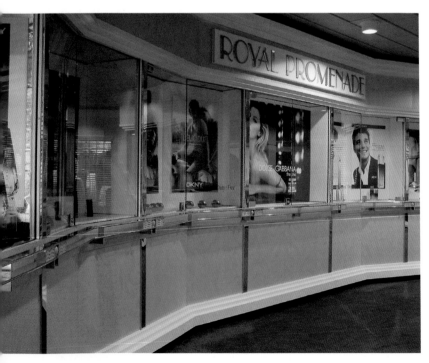

Originally located on One Deck, Harrods opened aboard *QE2* in 1984. It has been in its current location since 1999. Other famous brands to have graced the Royal Promenade over the years include Christian Dior, Cartier and Bally.

Due to maritime regulations, the duty-free shops are closed while the ship is in port.

THEATRE

The theatre is located on Upper Deck with a balcony level on Boat Deck. It retains much of its original décor from its fitting out in 1969.

Passengers can enjoy the latest movies, or old classics, on the large screen. Comfortable seating is provided for 500 in classic fold-down cinema chairs.

The Theatre is used extensively for the ship's lecture programme. A podium can be placed in the centre of the stage for this purpose. The Theatre is also home to a full-sized grand piano.

Interdenominational church services are held here on Sundays when the ship is at sea. These services are led by the captain or visiting clergymen. Catholic services are also held here in the evenings.

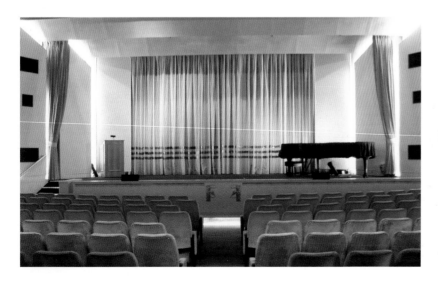

LIBRARY & BOOKSHOP

S ituated on Quarter Deck off the E stairway, the library and bookshop are some of the most popular places to visit aboard *QE2*.

And why not? With over 6,000 books to choose from, even repeat guests are sure to find a good read each time they're aboard!

For many years, *QE2*'s library was the only one at sea staffed with a full-time librarian – a tradition now carried on by all of the current Cunard ships.

The centrepiece of the library is a large cross-section model of the *Aquitania* which makes up part of the 'Heritage Trail' tour.

The bookshop is found just forward of the library and holds an extensive range of maritime books as well as souvenir items such as cards, bookmarks, charts, ocean liner art and memorabilia. Book signings are popular events aboard *QE2* and these take place just outside the library in the Quarter Deck promenade where a permanent desk is set up.

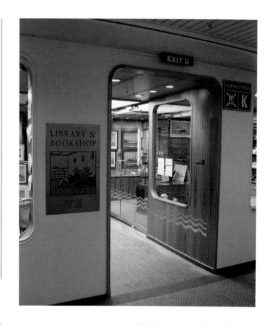

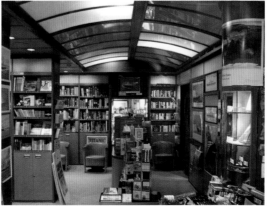

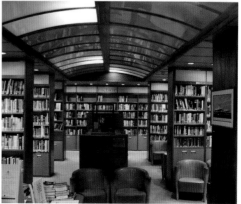

PURSER'S OFFICE

If you are seeking postage stamps, looking for factsheets, exchanging currency or paying for onboard purchases you will inevitably visit the Purser's Office.

Located aft of the Midships Lobby on Two Deck this room is the heart of business aboard *QE2*.

Originally the space housed a smaller reception desk as well as a separate Bureau de Change, however during the 1999 refurbishment the area was re-modelled, creating an elegant reception area with curved desk and granite floors.

DID YOU KNOW?

QE2 originally cost £29 million. Since her launch more than 15 times that amount has been spent in refitting her! She was sold in June 2007 for £50.5 million to Dubai World for transfer in November 2008.

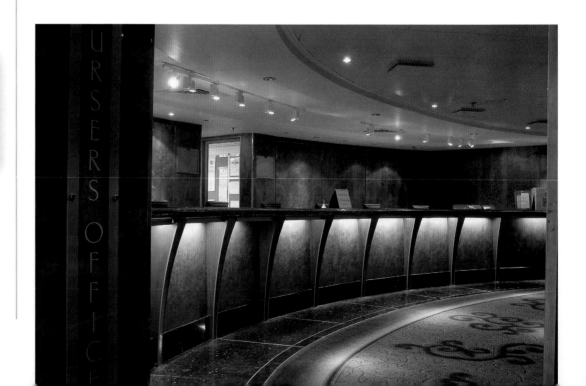

COMPUTER LEARNING CENTRE

Situated on the forward end of Two Deck is the Forward Lobby. Originally the tourist class entrance to the ship, this lobby is now used mainly at ports where the Midships Lobby is inaccessible.

Adjacent to the Forward Lobby is the Computer Learning Centre where passengers can brush up on their computer skills, or learn new ones. There is internet access available here for a premium fee which includes WiFi access in some bars.

A plaque commemorating the *QE2*'s service in the Falkland Islands campaign is found in the Forward Lobby and makes up part of the 'Heritage Trail' tour.

Below right: (Courtesy of Pam Massey)

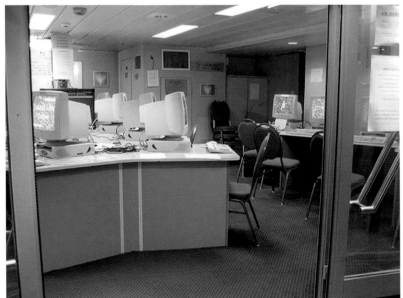

THE SYNAGOGUE

The Synagogue is found at the forward end of Three Deck, near the A Stairway. It is unique in that it is the only public room that has not been refurbished since the ship entered service. Designed by Professor Mischa Black from the Royal College of Art, it is a peaceful place of worship for those of the Jewish faith.

When put to sea in 1969 the *QE2* had a kosher kitchen. Although this was removed during the 1987 refurbishment, the Caronia galley has a kosher section that caters to the needs of Jewish passengers.

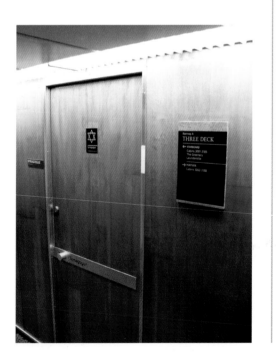

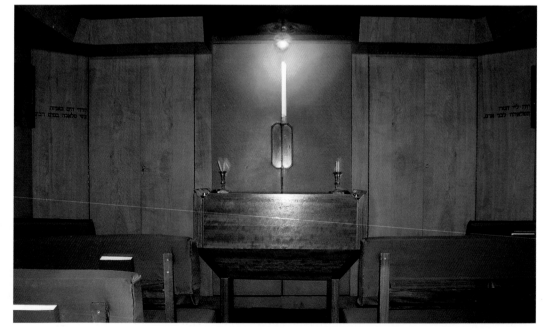

ROYAL CUNARD SPA

The Royal Cunard Spa is located on Six Deck and is accessed from the F Stairway and lift. The complex offers a variety of services including the large thalassotherapy pool, French hydrotherapy baths, saunas (male, female and unisex) and steam rooms. For those after more exotic treatments, the facility also offers seawater, Swedish, and Shiatsu massage.

The complex is operated by Steiner's of London, which also operates the beauty salon on One Deck. These two facilities, along with the Seven Deck gymnasium and pool, comprise the Royal Cunard Spa experience.

DID YOU KNOW?

When *QE2* is cruising the South Pacific, the water in the Royal Cunard Spa goes green.

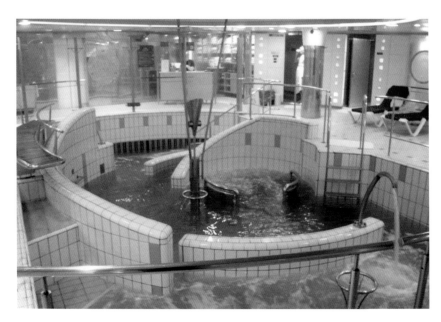
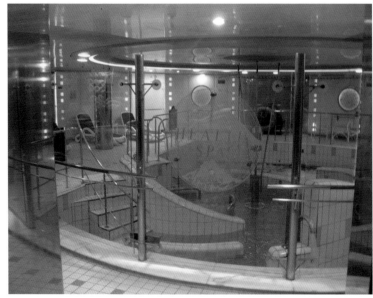

SEVEN DECK POOL AND GYMNASIUM

Below left and right: (Courtesy of Pam Massey)

For health-conscious passengers, or those who just feel they have eaten too much at the Midnight Buffet, Seven Deck is the place to visit! The gym is equipped with the latest Cybex weight-training equipment as well as treadmills, cross-trainers, exercise bikes, rowing machines and fit balls.

Fully trained fitness instructors are on hand to design a fitness programme for individual passengers' fitness goals. The gym is complemented by an indoor swimming pool, sauna and aerobics studio. There are changing rooms and showers available for passenger use.

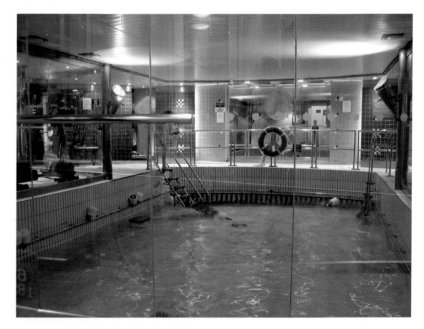
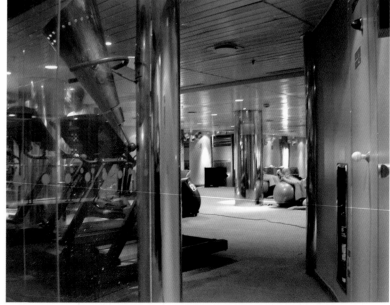

FOR THE KIDS

Despite the fact that the majority of *QE2*'s passengers are over fifty, there has always been great care given to offering thoughtful children's entertainment for those families travelling with youngsters.

Facilities include a nursery on Sun Deck which is staffed by traditional British nannies. This offers parents with very young children the opportunity to enjoy a 'night out' with the reassurance that their children are having fun in a safe and supervised environment! The nursery also comes complete with its own mini-cinema for the children to enjoy the latest videos.

For older children, the Junior Activity Centre on Upper Deck is the place to go. Located just forward of the Yacht Club on the Starboard side, the centre caters for children aged seven to twelve and teens aged thirteen+. Activities include arts and crafts, painting, hide-and-seek (around the ship) and pyjama parties.

The Pavilion offers a 'kids' menu' for youngsters, with favourites such as chicken nuggets and kids' burgers. This special dinner service starts at 5.30 p.m. allowing parents to supervise their child's meal before dressing for dinner in their own restaurant.

During the ship's 1994 refit, a video arcade was created aboard *QE2* and became known as Club 2000. Located forward of the Lido on the Port Side of Quarter Deck, this room offered a selection of arcade games as well as pin-ball and foosball. There was space adjacent for tables to be set up for parties which were popular with teens on transatlantic crossings. In recent years, this room has been closed and is now being used as a storeroom.

GETTING AROUND

Finding your way around *QE2* can be an adventure in itself. There are eight major stairways, six of which have lifts.

When the ship was originally designed it was planned to be used as a three-class vessel, however during fitting out this was changed and the ship emerged as a two-class liner, with First Class and Tourist Class.

As a result there are some stairways and lifts that only access certain decks, making things interesting for first time guests. For example, the F Stairway runs from Two Deck to Six Deck, while the A Stairway has no access to Quarter or One Deck when descending from Upper Deck to Two Deck. A good rule of thumb for ease of getting around is this: if you want to access every deck, use the E Stairway – just remember E stands for '**e**verywhere'.

Heard on the G Stairway:

'Excuse me, do these stairs go up or down?'

ART ABOARD

The *QE2* is a floating museum of Cunard art and memorabilia. Virtually every staircase, corridor and lobby tells the Cunard story.

The A Stairway houses 'modern art' commissioned for the ship in the late 1960s. In contrast the E Stairway is adorned with a retrospective of Cunard marketing posters from the 1930s. The G Stairway features in *QE2*'s 'Heritage Trail' tour for its exquisite maritime paintings depicting Cunard's long history.

Other popular areas of interest include the Three Deck D Stairway lobby which housed the ship's bell, used during Christenings to hold the holy water.

The Boat Deck landing of the D Stairway holds three tapestries by Helen Banynina Hernmarck, depicting the ship's launch at Clydebank in 1967. D Stairway is also home to portraits of HRH Princess Elizabeth and the Duke of Edinburgh, as well as Queen Elizabeth, the Queen Mother. The latter hung aboard *Queen Elizabeth* (1938) while the former graced *Caronia* (1949).

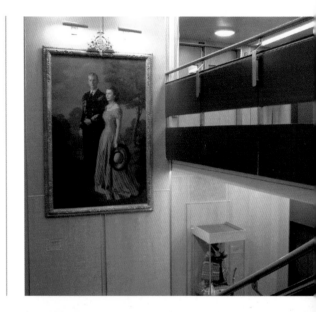

MODELS AND COLLECTIONS

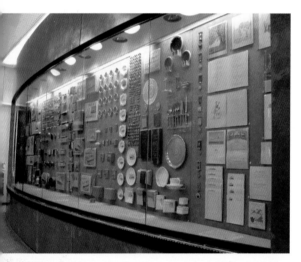

There are many models and collectable items displayed around the ship. These form part of the Cunard 'Heritage Trail' that was introduced to the ship after her 1994 refit. Models include the early Cunard ships such as *Britannia*, as well as *Mauretania* (of 1907) and *Caronia* (of 1949) which both feature on Quarter Deck outside the Caronia Restaurant.

Some of the most interesting items on display are found in Peter Radmore's collection of Cunard Memorabilia which is displayed in a large glass cabinet on the Upper Deck landing of D Stairway. He bequeathed the items to Cunard in his will and, amazingly, these pieces form only a small percentage of his total Cunard collection.

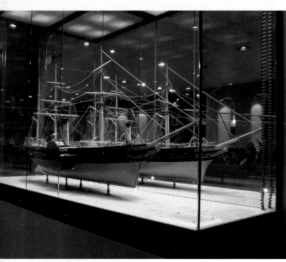

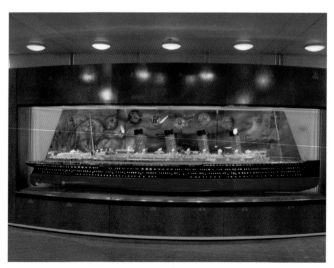

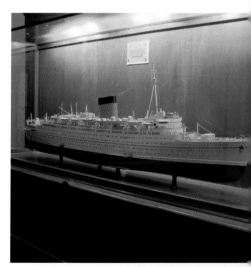

ON DECK

There is a vast amount of open teakwood deck space on *QE2* for passengers to stroll, relax and enjoy the view.

The decks are scattered with classic steamer deckchairs for passengers to lounge on. Many a day has been spent by passengers on a *QE2* deckchair with a good book and a cocktail from one of the deck bar staff.

If you're travelling with someone special, the decks are the perfect place to watch a sunset and then take a romantic moonlit walk.

BOAT DECK

A stroll around Boat Deck while the ship is at sea is one of life's little luxuries. Five times around the Boat Deck and you've walked a mile!

Shade is provided by the ship's twenty lifeboats, six of which are used as tenders when *QE2* is anchored in a port too small to accommodate her.

There are various entrances into the ship – those on the Port side were upgraded to allow for wheelchair access.

OBSERVATION DECK

The Observation Deck is extremely popular with passengers, especially when the ship is arriving or departing from a port, as it is the only public area on *QE2* with a forward-facing view. The Observation Deck is located at the forward end of Sun Deck but is accessible only from Boat Deck via stairs on the Port and Starboard sides. Standing here on a clear day provides spectacular views as far as the horizon (the same view as from the Bridge above). However, when the ship is sailing at speed, this area is often closed due to extremely high winds.

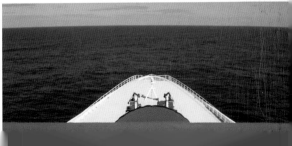

'DOGGY DECK'

I f you wish to take your favourite pet with you across the Atlantic, *QE2* is the way to go! There is a fully operational kennel service aboard the ship, located amidships on Sun Deck.

The kennels have impressive amenities including a 'doggy deck' for exercise and a London lamp post to ensure that the dogs feel right at home. Passengers are welcome to visit their pets during the voyage to reduce any separation anxiety!

SPORTS CENTRE

Whether you are athletically inclined or enjoy the challenge of learning a new game, you'll find a range of activities at the Sports Centre to keep you entertained. An open-air facility on Boat Deck aft, the Sports Centre offers panoramic views in addition to sporting facilities.

There is a basketball ring for those who fancy shooting some hoops, a paddle tennis court and even a putting green and driving range allowing golfers to keep in practice while they are hundreds of nautical miles from the nearest golf course.

As one would expect aboard *QE2*, there are also the traditional ocean liner games of shuffleboard and deck quoits. Friendly tournaments are often held at the Sports Centre, where passengers can compete for pride and prizes.

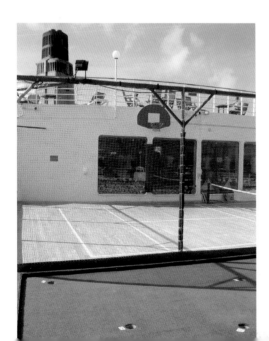

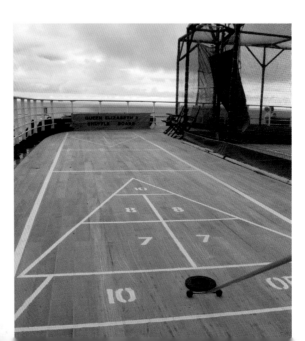

ONE DECK POOL

The One Deck pool is located at the stern of the ship, providing a fantastic view of the *QE2*'s wake as she powers through the ocean.

The pool area consists of a deep seawater pool as well as a kids' wading pool and two whirlpools. It is surrounded by deckchairs for people to relax and soak up some sun. This area is often used for ice sculpting demonstrations. It was also used as King Neptune's Court when the ship crossed the line (the Equator) – *QE2* crossed the Equator for the last time on 9 March 2008.

POOL POWER!

In 1983, when *QE2* was requisitioned by the Admiralty during the Falklands Crisis, the aft end of Upper and Quarter Deck were cut off and stored. This allowed for the addition of a heli-deck to be built over the One Deck pool.

This location was perfect for such a conversion as the pool area was already reinforced to be able to hold the weight of the pool water

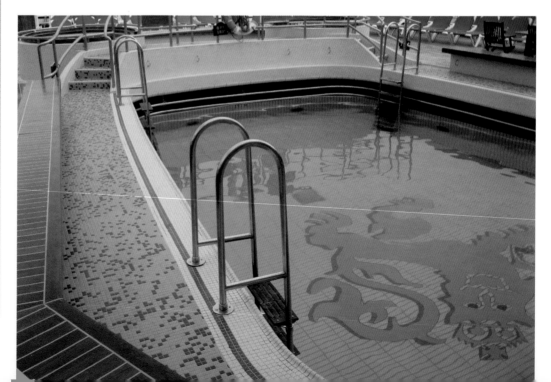

CREW ONLY

There are 1,040 crew members working behind the scenes to ensure that each day aboard *QE2* runs smoothly. Often the crew's actions go unnoticed, hidden behind discretely placed 'Crew Only' signs.

The 'Crew Only' areas span across all decks, from the Bridge high atop Signal Deck to the Engine Room below the waterline. A team of so-called 'crew's crew' work tirelessly, ensuring the crew are fed and comfortable.

The crew eat in the Crew Mess, located within the superstructure on One Deck. The Crew Mess operates on a rotational basis with different shifts having different meal times. Meals are served in a buffet style with a selection of meats, salads, vegetables and desserts.

Further forward on One Deck, the crew can get some fresh air while the ship is in port. Large doors lead out onto the open deck that stretches to the very front of the ship. When the ship is underway, watertight doors are closed to keep the elements at bay.

The crew have various options for entertainment when they are off duty. The Pig & Whistle is *QE2*'s crew pub. The name is a tradition on Cunard ships and one will also be found aboard *Queen Mary 2*, *Queen Victoria* and *Queen Elizabeth.*

The Pig & Whistle shows a vast contrast in the style of décor to that which the passengers experience, retaining a strong 1960s theme of chrome and aluminium.

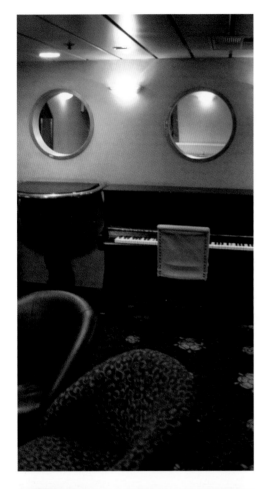

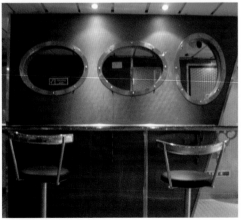

In comparison, the Fo'c'sle Club has a more homely feel, with furniture which has been taken from public rooms during various refurbishments and carpets of the same design as that found in the Queens Room. A widescreen television can be used to view sporting events while a piano provides musical entertainment.

For those crew members who fancy dancing the night away, Castaways is the crew's nightclub, while the Officers' Wardroom provides a more refined and relaxing environment with a good selection of brandy and forward-facing views.

Crew events cause great excitement among the staff, especially in the case of the annual tug-of-war. The winning team is immortalised on a plaque displayed in the Crew Mess along with samples of the ropes used to attain victory.

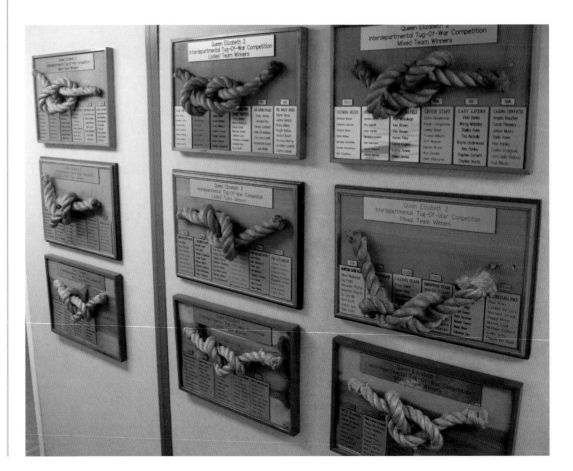

THE BRIDGE

Because most passengers never have the chance to visit the Bridge they are unaware of the amount of work that goes on there.

Situated at the forward end of Signal Deck, the Bridge is the one of the most important rooms on the *QE2*. It is from here that the ship is navigated safely from port to port. The Chart Room (not the bar!) is also located here and stores about 1,600 charts which cover the majority of the world's oceans.

The Bridge is also the primary response area for any emergency situations. Water-tight doors, emergency systems, fire doors, alarms and the horn are all operated and monitored from here. When the *QE2* is entering or leaving a port, the pilot is stationed on the Bridge.

DID YOU KNOW?

The *QE2*'s Bridge is often referred to by its officers as 'The Tank' due to its small size!

BEHIND THE SCENES

S hipboard maintenance is a familiar sight to any *QE2* passenger. Painting the ship is virtually a 24-hour, seven-days a week job. Every time the ship docks, the paint crew take the opportunity to ensure the ship's hull and superstructure present at their best.

While the ship is at sea the paint crew busy themselves ensuring the decks, corridors, lifeboats and equipment is painted and maintained.

DID YOU KNOW?

QE2's forward crane (located on the forward end of Quarter Deck) can carry an impressive 5-ton load!

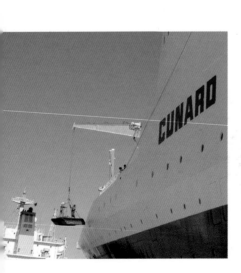
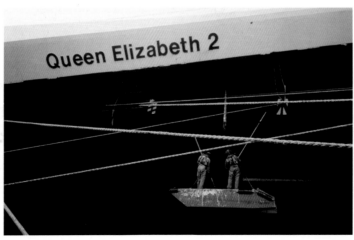
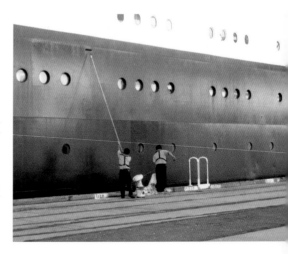

THE STORES

On a ship the size of *QE2* a vast amount of fresh produce and stores need to be transported to ensure that the passengers and crew never go hungry.

During cruises the ship restocks in many ports, ensuring that the food is always fresh. As a result of this, a group of four passengers all ordering a can of Coca-Cola could each find theirs has come from a different country.

Food and beverage storerooms take up most of Seven Deck and are under constant lock and key. Areas that receive particular security include the chocolate store which also houses the caviar and saffron.

Who says good service doesn't pay? A wealthy passenger that many crew will never forget once threw the party of a lifetime when he bought the entire contents of the ship's champagne cellar and donated it to the crew.

DID YOU KNOW?

Some passengers bring their own provisions aboard. The caviar cage is often home to private *foie gras* and caviar stashes.

Below left: The Chocolate Store.

Below centre: The White Wine and Champagne Store.

Below right: Loading cereal aboard the *QE2*.

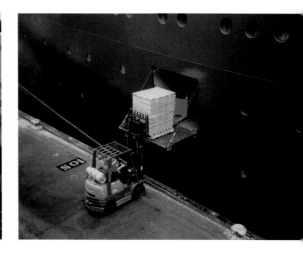

POWER PLANT

Below right: Five of the nine MAN B&W engines running horizontally across the picture.

Opposite left: The propeller blades as installed in 1987. (Courtesy of Commodore R.W. Warwick, *QE2: The Cunard Line Flagship* Queen Elizabeth II)

Opposite right: The Starboard propeller shaft.

When *QE2* was first put into service she was powered by John Brown-built steam turbine engines. The ship's boilers were the largest to be incorporated into a ship at the time, each weighing an impressive 278 tons!

The ship's original propellers, at a cost of £500,000 each, had six blades apiece and weighed 31.75 tons. These engines and propellers served *QE2* for seventeen years, but by the mid-1980s they were becoming unreliable.

The decision was made to re-engine the ship. This mammoth job was undertaken in Bremerhaven, Germany and, along with an internal refit, cost £180 million! The original power plant was replaced with nine MAN B&W diesel electric engines (each the size of a

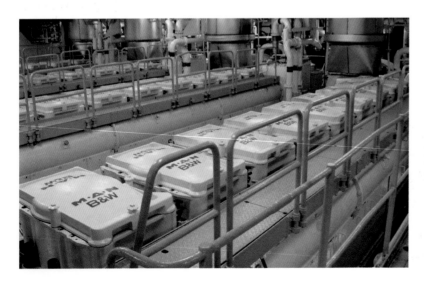

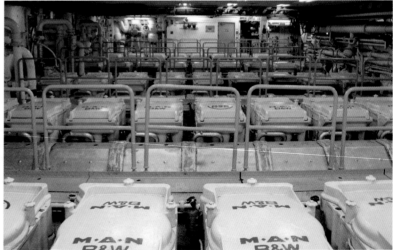

double-decker bus) powering two electric propulsion motors that drove the new five-bladed controllable pitch propellers.

To accommodate this feat of engineering the original funnel was removed and stored on the dock. The steam turbines and their accompanying equipment were removed through the funnel shaft. This space was then used to lower the new engines into place. A new, wider funnel was rebuilt, incorporating some of the original cowling, to accommodate the new engine exhaust pipes. The entire process was the largest works undertaken on a merchant vessel at the time, beginning in October 1986 and taking until April 1987 to complete.

QE2's diesel electric plant was selected for its well-known reliability. Each engine is a medium-speed nine-cylinder turbo-charged diesel engine which runs at 400 revolutions per minute.

Heard on a 1998 Bridge Tour:

'Does the ship generate its own electricity?' To which the officer replied, 'No sir, we have awfully long extension cords'.

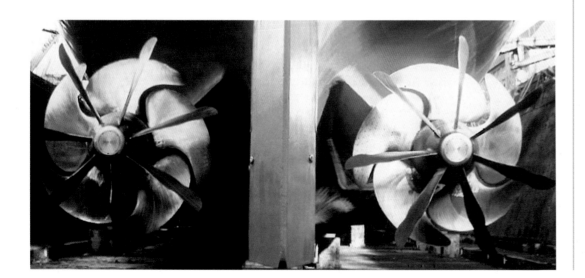

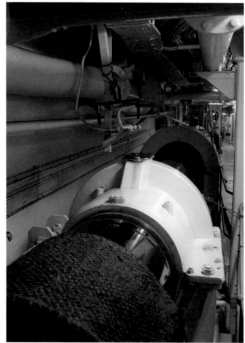

DID YOU KNOW?

By the end of her career, *QE2* had sailed 5.875 million nautical miles. This equals more than *Queen Mary* (1936) and *Queen Elizabeth* (1940) combined.

The diesel plant produces electricity which is used to power the ship's essential services as well as two propulsion motors – one on each propeller shaft. These motors always run at 144 revolutions per minute. *QE2*'s speed and direction are manipulated by variable pitch propellers.

QE2's service speed of 28.5 knots can be achieved using only seven of the nine available engines, allowing for maintenance to be carried out at sea. There is always one engine running while the ship is in port to supply hotel services.

The total output of *QE2*'s power plant is 95MW or 127,345hp. This is enough electricity to light the City of Southampton.

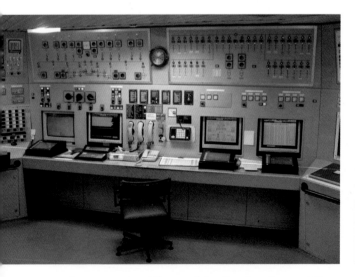

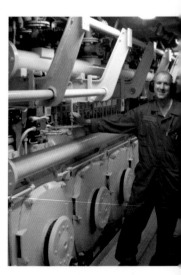

Left and centre: Views of the Engine Control Room. **Right:** Chief Engineer Paul Yeoman with his engines.

THE MASTER'S DUTY

Commodore R.W. Warwick gives some insight into the life of the *QE2*'s captain.

THE ROLE OF THE CAPTAIN

The *QE2* is self-managed under the command of the Master. This means that all aspects of the running of the ship are ultimately the responsibility of the captain. Aside from the successful navigation from port to port, the Master's prime responsibility is ensuring the safety of the passengers and crew and also the *QE2* herself. The *QE2* often carries more than 2,500 people; the equivalent of a small town at sea. As such, the Master's job can often be compared to that of a mayor. Responsibilities include maintaining order, liaising with those aboard, marketing the vessel to future passengers and receiving dignitaries (including the Queen in *QE2*'s case). The Master also has the responsibility to report to the various directors of the company and to represent the ship's crew at company meetings.

Essentially very little has changed in the primary role of Master of the *QE2* since Commodore W.E. Warwick first took her to sea nearly forty years ago. However, technological advances have allowed the ship to become far more efficient and safe. When the *QE2* was first put to sea, communication between the ship, land and other vessels was via Morse code! There have been various improvements in the fire detection equipment aboard, as well as the introduction of satellite navigation and GPS; however, the traditional paper charts are still maintained as an important part of the ship's navigation.

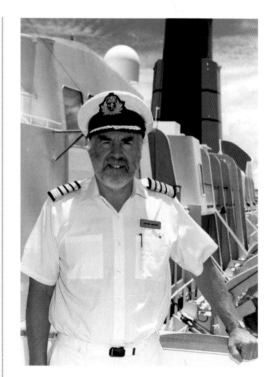

(Courtesy of Commodore R.W. Warwick)

THE WARWICKS

A unique event in the Cunard Line's history occurred on 26 July 1990 when Captain Ronald W. Warwick was appointed as Master of *QE2*. Never before in the company's long history had a son commanded the same ship as his father. Commodore William E. Warwick was *QE2*'s first Master. He was appointed to the ship while she was under construction in Clydebank and first set eyes on his new command in December 1966.

At this time his son, Ronald, was the Chief Officer aboard a freighter on the England–Jamaica run.

QE2 visited Jamaica in 1969, which coincided with Ronald Warwick's vessel being in the same port. As his father was Master of *QE2* he took this opportunity to visit the new flagship of the British Merchant Navy. Shortly afterwards he joined the Cunard Line and in April 1970 was appointed to stand by *QE2* while she was in dry dock in Southampton.

Commodore William E. Warwick took shore leave while *QE2* was in dry dock and as such only worked with his son for one day. Shortly afterwards Ronald W. Warwick was appointed to *Carmania* as a Third Officer.

Ronald Warwick returned to *QE2* after his father retired and gradually worked his way through the Cunard Line, taking command of the *Cunard Princess* and *Cunard Dynasty* before being appointed as Master of *QE2* in July 1990. This appointment occurred during the company's 150th Anniversary. To mark this momentous occasion, HM Queen Elizabeth II and the Duke of Edinburgh attended a review of the Cunard fleet in Southampton.

Captain Ronald W. Warwick was appointed to Commodore of the Cunard Fleet in 2003, and in June 2005 was awarded an OBE during the Queen's Birthday Celebrations. He retired in 2006, after commanding the new *Queen Mary 2*.

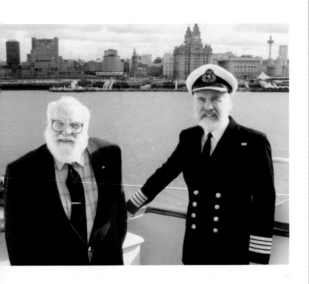

Commodores W.E. and R.W. Warwick
(Courtesy of Commodore R.W. Warwick)

A SPECIAL SHIP

Commodore Christopher Rynd, of the Cunard Line, recalls commanding QE2.

She was, of course, to a seafarer the best-known ship in service in the world. I recall seeing her in my own career in ports around the world but never for a moment considered I might one day serve there, let alone in command.

I joined QE2 in June 2005, transferring from a sister company and moving from their newest vessel to this iconic liner, working alongside Captain Nick Bates during my familiarisation. The opportunity had presented itself with a change of management and I volunteered. It was a unique chance to experience a national treasure and bit of living history. My early career had been in passenger ships of her era and two early commands had been in vessels with similar propulsion and handling characteristics so this was to revisit the past.

I was fascinated by the QE2. Familiarising with the ship, visiting every accessible space, finding my way about in what was a difficult layout to learn as any who sailed in her will know. Discoveries of by then unused equipment such as the arrangements for carrying private cars, and the fitted beer storage below decks right up in the bows. A stern anchor to employ, the kennels with a lamp post for doggies. And many other nooks and features. Nine diesel generators and the largest propulsion motors built at that time. Such power. I recall an early passage up the North Sea with 4.5m head swells and she just sliced through them. In her element, like none other I had known. I recall I had to share this with colleagues at the time, needed to tell them. Similarly, when I first had need of her speed. Making 29 knots en route to Boston from Halifax. And, of course, the sound of her whistle thrilled all who heard it.

As a ship to manoeuvre she required all the skills one could muster. She will remain one of the most memorable times in my seagoing career. I was privileged to have command of this legendary vessel on two appointments before transferring to her successor, Queen Mary 2.

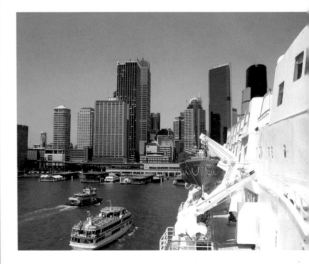

QE2 berthed at Circular Quay in 2006.

A REGAL PROFILE

The *QE2* has been an icon in maritime circles for four decades. Her shape maintains a timeless and elegant quality, bringing to mind images of ships from bygone eras. She retains the beauty of a true thoroughbred, with features inherited from the likes of *Aquitania* and *Queen Mary*. These include her spectacular long bow with her Bridge set high atop the superstructure.

Elegant straight lines are complemented by her rounded stern. Her single funnel is adorned with the Cunard red and black, while her stylish mast flies the house flag of the company that gave birth to the scheduled Atlantic crossing.

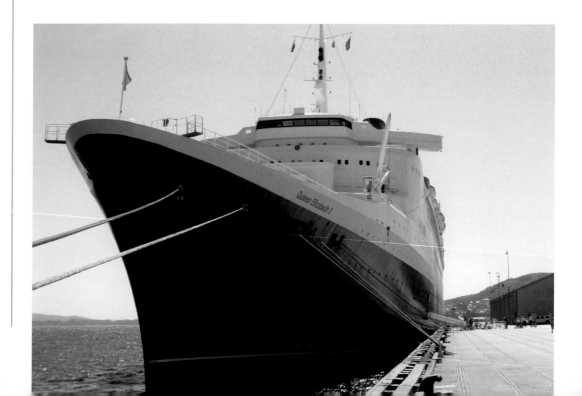

ELEGANT LINES

The *QE2*'s profile is both beautiful and regal, as anyone who has seen her can attest. This is owed largely to the time when she was built and her primary purpose as a transatlantic liner.

Unlike modern cruise ships, which are built to accommodate their interior design, the *QE2*'s interior was designed to fit her external form. The ship has an extremely long bow, with the superstructure set further back than modern vessels, which allowed for nearly forty years of Atlantic crossings.

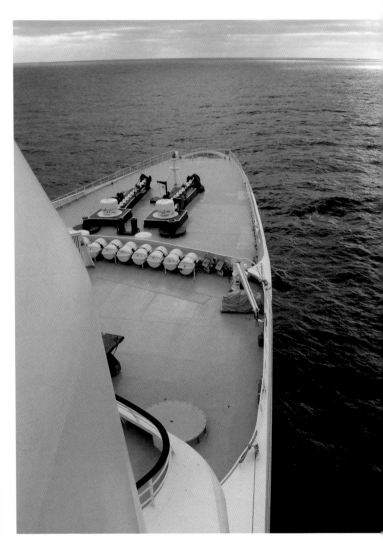

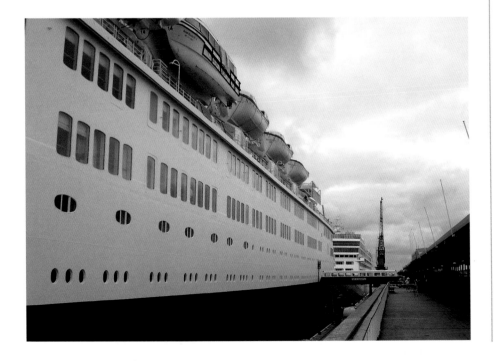

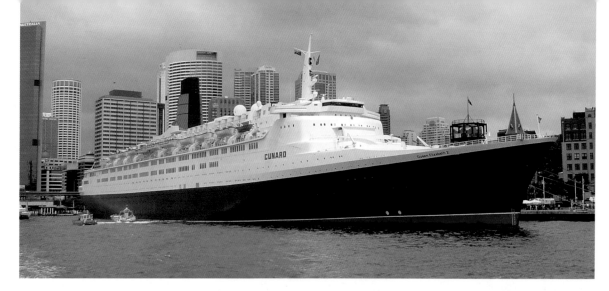

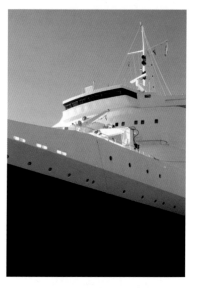

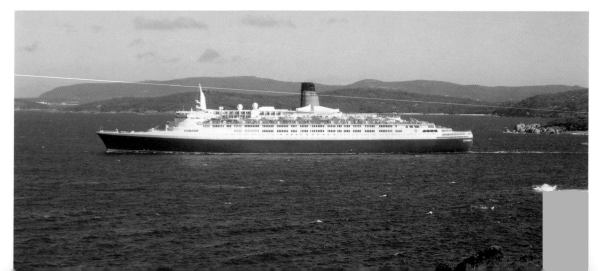

(Lower image:
Courtesy of
Jan Frame)

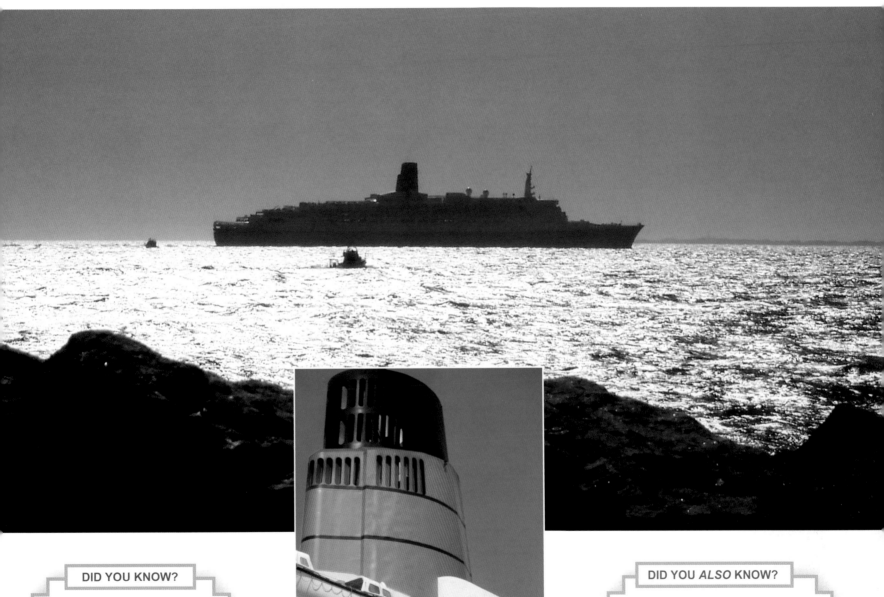

DID YOU KNOW?

The *QE2* has twenty-four lifts. Thirteen of these are for passenger use, two for cars, eight in storage areas and one in the engine room.

DID YOU *ALSO* KNOW?

Approximately 600,000 litres of beverage are consumed on board annually! The number of teabags used each day on the *QE2* would supply a family for an entire year!

THE FUNNEL

Cunard funnels are instantly recognisable, but *QE2*'s funnel is more distinctive than most due to its unique shape. The original funnel was thinner and was painted black and white – a vast departure from the traditional Cunard image.

The colours were changed to the distinctive red and black which we see today during the 1980s, while the funnel itself was re-designed during the ship's 1986/87 re-engineering in Bremerhaven, making it wider (to accommodate the nine diesel exhaust pipes) and giving the ship a more powerful profile.

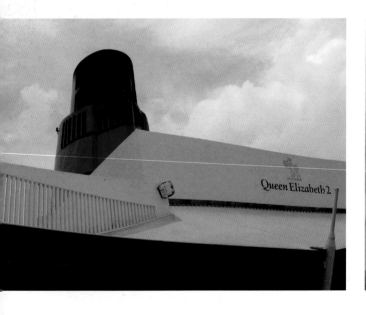

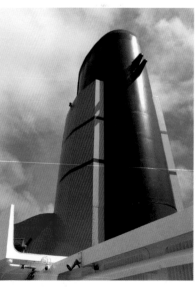

THE MAST

The mast is the second tallest point on the ship after the funnel. It reaches to 51.54m above the water line.

The mast is actually a cleverly hidden second funnel – providing ventilation for the ship's galleys. Atop the mast there are two horns (traditionally called whistles) which are sounded when the ship enters and leaves a port. They are also sounded when sailing through fog, or to warn off smaller vessels that may be in QE2's path.

The mast is pivotal to the ship's navigation as it holds the radars, satellite antennae and signal lighting (which tells other ships which direction the QE2 is sailing).

The mast displays various flags while at sea and in port. The Courtesy Ensign is the flag of the country being visited, and is flown at the highest point of the mast. The British Ensign is flown from the gaff (as well as the stern staff), while the Cunard House Flag is flown from the yardarm, as are signal flags.

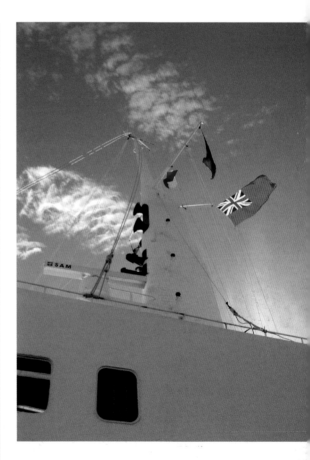

DID YOU KNOW?

Commodore R.W. Warwick explains that a ship in the British Merchant Navy flies a Red Ensign. However, a Royal Naval officer can obtain a warrant from the Admiralty to fly the Blue Ensign (which is flown on naval vessels). As a retired officer in the Royal Naval Reserve, Commodore Warwick had the option to fly either the Red or Blue Ensign when in command of the QE2. His preference, however, was for the Red Ensign.

DRESSED UP

Unlike most of today's passenger ships, which sport a white colour scheme, the QE2's hull is painted matte black. Ships travelling the transatlantic crossing face far more exposure to inclement seas, which can cause damage to the paintwork. Having the black hull not only helps to mask chipped paint, but also absorbs heat, helping to warm the ship when travelling in the cold climates of the Atlantic Ocean.

For a short time in the 1980s, QE2's hull was painted a light 'pebble grey' colour. This was unpopular in appearance and difficult to maintain. After only a few months it reverted to the original darker colour scheme.

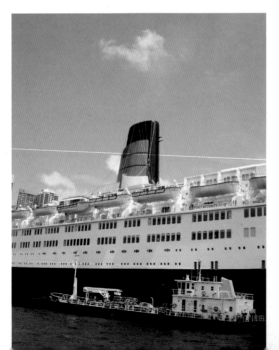

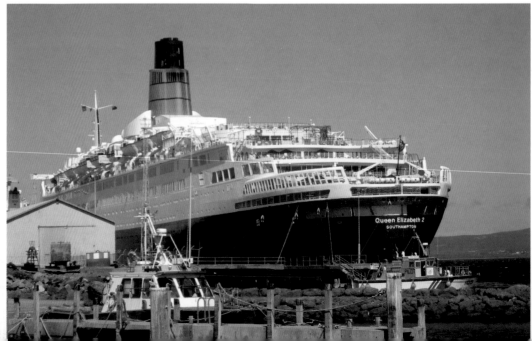

PILOT BOATS

I t is the job of a pilot to bring ships safely in and out of port. The pilot is ferried to and from shore in the aptly named 'pilot boats', which are small and easily manoeuvrable vessels often painted in distinctive orange and blue.

The *QE2* takes on a marine pilot when entering or leaving a port, or a crowded waterway such as the Panama Canal. While the captain knows the ship best, the pilot is extremely familiar with their particular waterway. The pilot enters and departs the *QE2* via a doorway in the hull on Five Deck and is escorted to the Bridge for his or her time aboard.

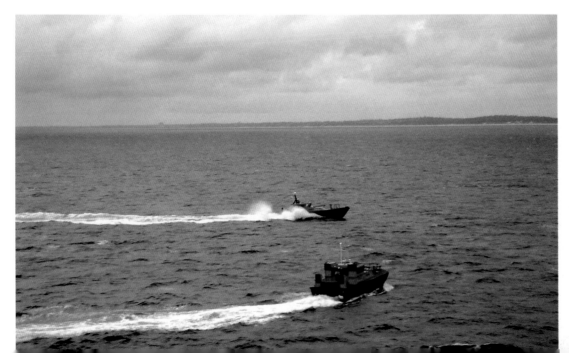

THE TUGS

When the *QE2* first entered service she was one of the most modern ships afloat. The ship not only carried four Denny-Brown stabilisers for a smoother journey, but also two bow thrusters allowing her to manoeuvre more easily in close quarters. These days, however, ships are fitted with up to three bow thrusters and often stern thrusters or rotating propeller pods, allowing them to berth without the assistance of tugboats.

The *QE2* still requires tugs to help get her in and out of port. There are often three and sometimes four tugs, depending on the difficulty of the port being entered. This creates a great show for passengers on the ship as well as those ashore, as the tugs and the ship seem to act as one, allowing a seamless entry and departure into even the trickiest quay.

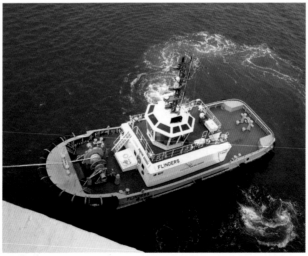
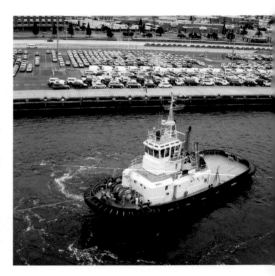

MEETING OF THE QUEENS

SISTERS IN SYDNEY

The afternoon of 20 February 2007 marked a momentous occasion, when the *QE2* entered Sydney Harbour to meet her 'big little sister', *Queen Mary 2*. It was the first time that two Cunard Queens had been together in Sydney Harbour since the Second World War, when *Queen Mary* and *Queen Elizabeth* had met there on their way to the Middle East. *Queen Mary 2* arrived early in the day amid a flotilla of small boats and thousands of bystanders. In the afternoon even more Sydneysiders flocked to the

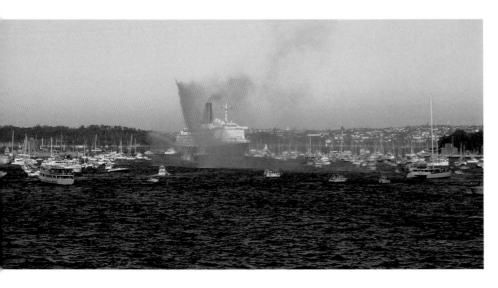
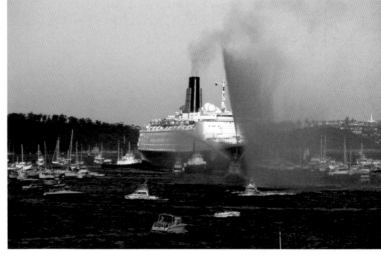

harbour to witness the *QE2* pass by *Queen Mary 2*. The *QE2* was escorted by a fireboat and hundreds of private boats as well as the Sydney ferries.

The number of people on and around the harbour on 20 February 2007 was overwhelming for the crew of the two Cunard Queens. No-one, including the Sydney authorities, had expected such a magnificent turnout. Traffic was at almost a standstill as hundreds of thousands crowded Circular Quay. Every single vantage point along the shore of the harbour was occupied by onlookers.

Queen Mary 2 was visible from the Garden Island Naval Base at Woolloomooloo as the *QE2* rounded Bradley's Head. This gave onlookers the unique opportunity to see the two ships in close quarters.

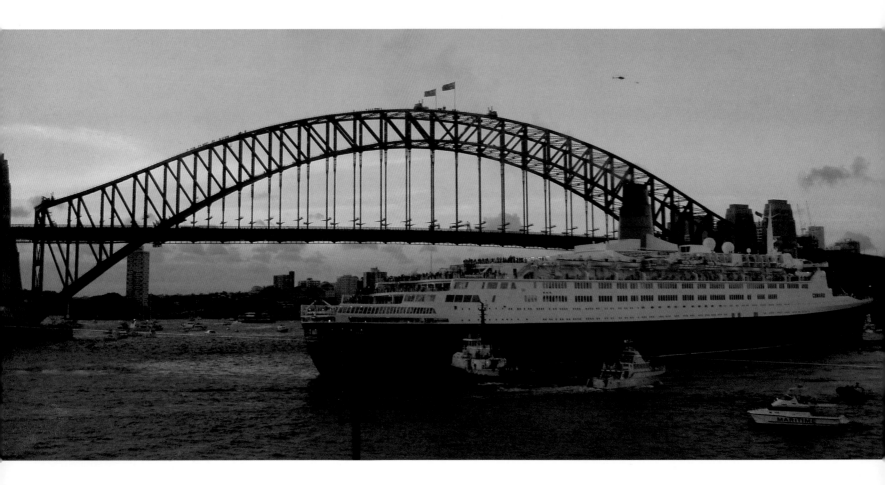

There have been several other occasions when the *QE2* was joined in port by her fleetmates. One of the most historic of these occasions took place in January 2008 when, after a tandem North Atlantic Crossing, the *QE2* and the new *Queen Victoria* entered New York Harbour. Here they met the *Queen Mary 2*, resulting in the first and only time that these three Cunard Queens would be together in New York.

The three departed that evening in a carefully orchestrated event which involved them pausing near the Statue of Liberty to view a fireworks display in their honour. The *QE2* then continued on her twenty-sixth and final world cruise, meeting *Queen Victoria* again in Fort Lauderdale and later in Sydney. The three ships met for the final time under the Cunard flag in Southampton in April 2008.

DID YOU KNOW?

The *QE2* has a car garage which allows her to transport passengers' vehicles. This was particularly handy for passengers 'crossing the pond' who wanted to take their cars with them!

Below left and right: (Courtesy of Thad Constantine)

A ROYAL RENDEZVOUS

O n 24 February 2008 *Queen Victoria* and *Queen Elizabeth 2* met in Sydney Harbour for the first and final time. Sydneysiders came out in force to watch this historic rendezvous. The two ships left from their respective berths to salute each other as they passed on either side of Fort Dennison.

DID YOU KNOW?

QE2's final arrival in Sydney occured 30 years to the day since her maiden arrival there in 1978.

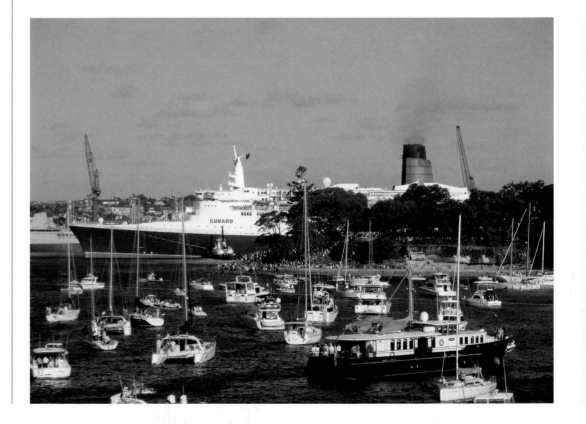

Queen Victoria then continued on her maiden world cruise, to her next port in Brisbane. The QE2 docked at the Overseas Passenger Terminal in Sydney overnight before bidding the city farewell for the last time.

DID YOU KNOW?

The QE2's official letters were G.B.T.T. which were painted atop the bridge for easy aerial identification.

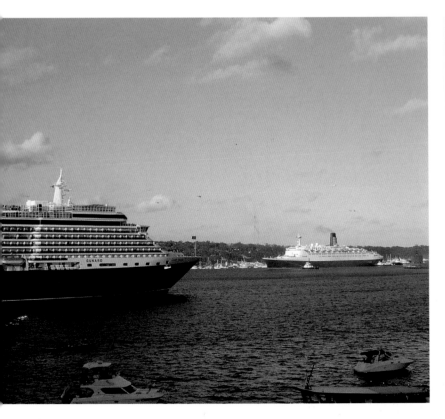

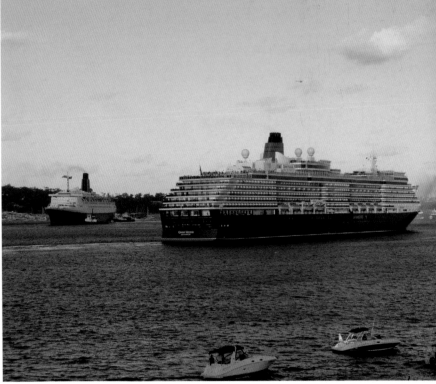

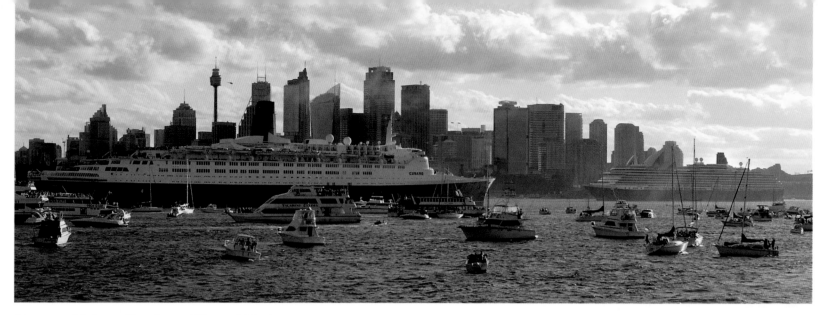

Above and below: (Courtesy of Cunard Line)

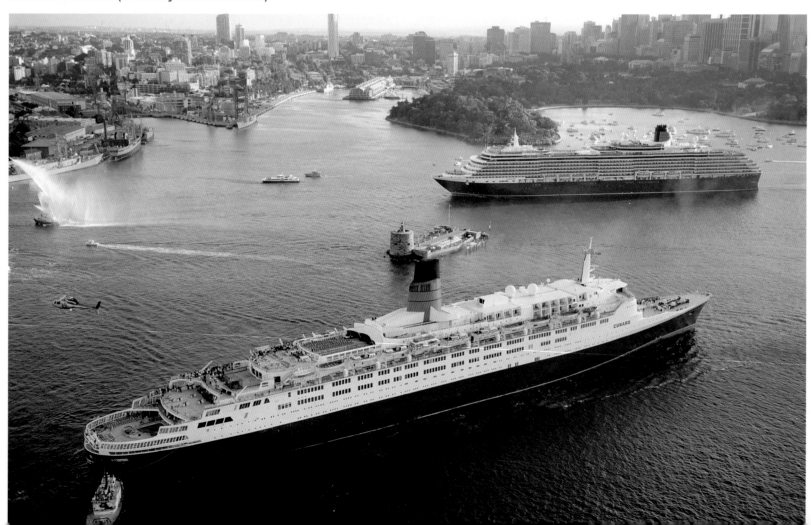

CRUISING THE WORLD

Well known around the world, the *QE2* completed twenty-six world cruises before being retired in November 2008. Her itineraries have taken her to such varied destinations as the Norwegian Fjords, Alexandria in Egypt and Carnaval in Rio!

Below left: The *QE2* off Guernsey.
(Courtesy of Pam Massey)

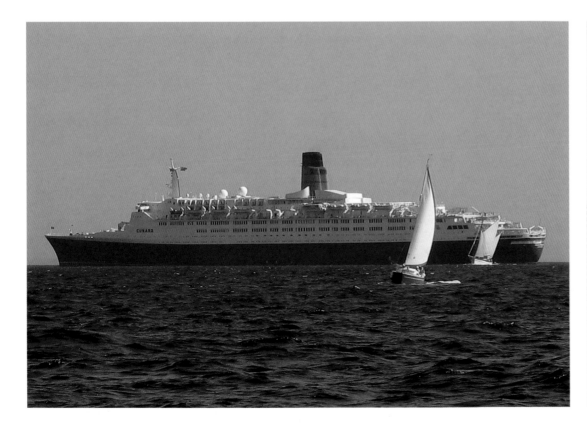

An icon herself, the *QE2* is perfectly at home against the backdrops of such landmarks as the Sydney Harbour Bridge in Australia and the Auckland Skytower in New Zealand.

Since her introduction into service the *QE2* has called Southampton home. In her later years, after being replaced by *Queen Mary 2* on the transatlantic run, the *QE2* was positioned in Southampton year round (with the exception of the annual world cruise). Southampton was also the ship's Port of Registration as displayed on her stern.

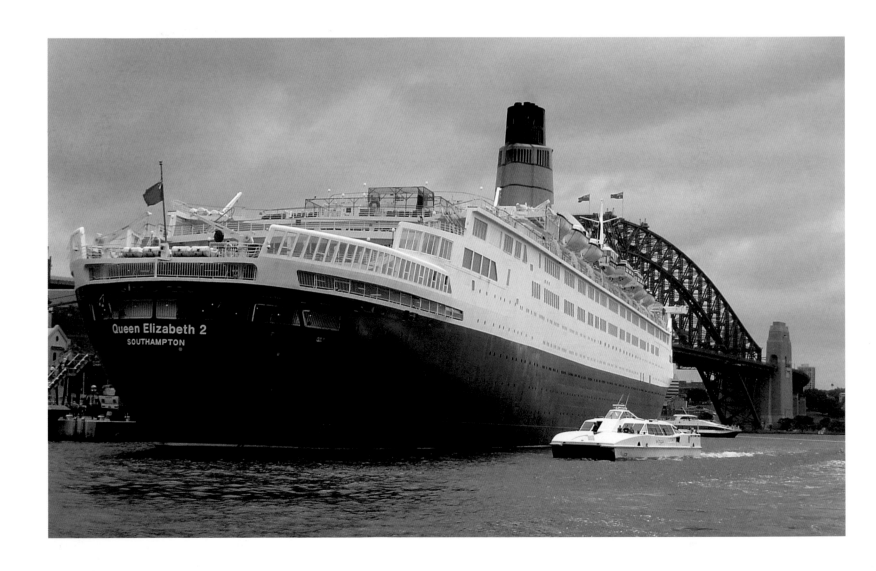

Part of the initial design brief was that the ship had to be able to undertake world cruises. Hence, she had to be able to fit through the locks of the Panama Canal (Panamax Standard). The *QE2*, at 105ft wide, just manages to enter the locks which are only 5ft wider than the ship! The transit of the canal takes approximately 8 hours, but is dependent on the number of other ships making the passage.

From Acapulco (Mexico) to Albany (Australia) – the *QE2* drew a crowd at every port she visited. She attracted attention in Dubai and will continue to do so whatever her future holds.

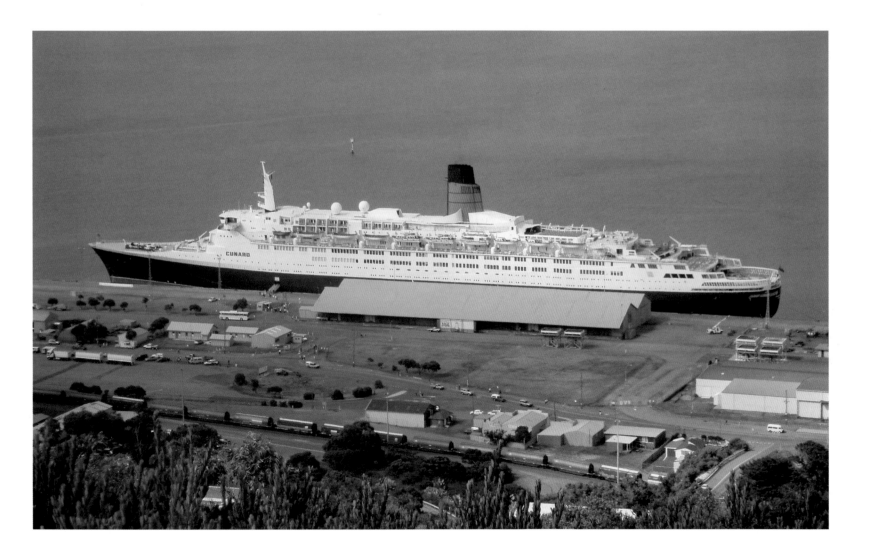

This photograph was taken from the *QE2* in the Gatún lock in the Panama Canal during her 1998 world cruise. The other ship that can be seen is the *Regal Princess* of Princess Cruise Line (now *Pacific Dawn* of P&O Cruises).

QE2 in Southampton. (Courtesy of Pam Massey)

DID YOU KNOW?

The launderette on Three Deck is considered by many passengers and crew as being the most dangerous room aboard. More arguments break out there than in any other room.

FAREWELL

Below and opposite page: Australia's goodbye to *QE2*: thousands line the shore in Port Adelaide as she passes; the ship leaving Australia for the last time.

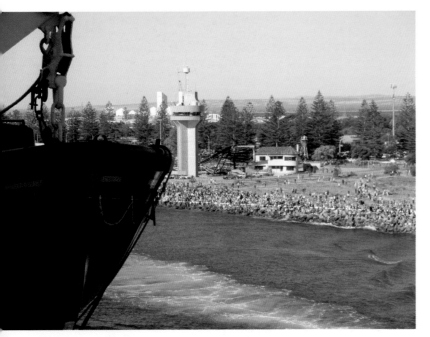

The year 2007 was heralded as the *QE2*'s fortieth anniversary. The date 20 September 2007 marked forty years since the *Queen* had given the *QE2* her name on the Clyde. It had been forty years since the great hull had floated for the very first time. And forty years since the most famous ship in the world was born.

To mark this anniversary a series of celebratory voyages were organised, including the hallmark round-Britain celebration which saw the *QE2* return to her birthplace. This momentous year in the ship's history was to be overshadowed when, on 18 June, her retirement was announced. The *QE2* had been sold to Istithmar for US$100 million. The new owners planned to spend months refurbishing the ship before opening her as a floating hotel.

The sale of the *QE2*, which included the priceless Heritage Trail, came as a surprise to many around the world, while others accepted the inevitable. By the time she retired, the *QE2* had sailed more than 5.8 million miles – the furthest distance of any ship, ever.

The 2008 world cruise quickly became known as the 'Farewell World Cruise' and the people of the world responded. The *QE2* has always attracted a crowd, but after 18 June 2007, whether lining the shores or taking to the ocean in private boats, people everywhere made a special effort to bid their own farewell to the *QE2*. These farewells reached their climax on 11 November 2008, when the *QE2* embarked on the aptly named '*QE2*'s Final Voyage' – a sixteen-night sailing that saw her leave Southampton and Britain for the very last time, bound for Dubai.

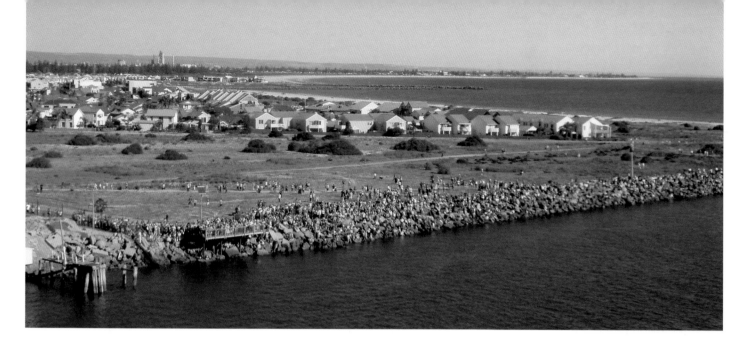

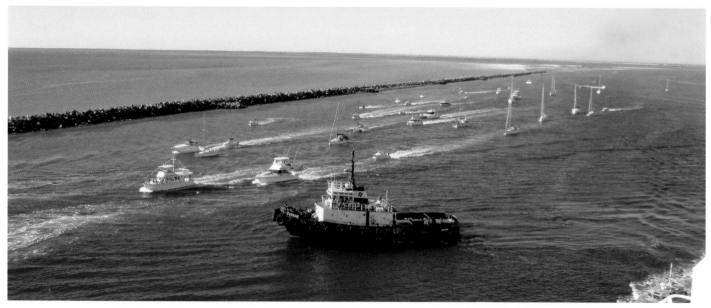

FREMANTLE PORT FAREWELLS

DID YOU KNOW?

There have been multiple plans for *QE2*'s future since her arrival in Dubai, including use as a hotel in Cape Town, Fremantle, Liverpool, the Far East and even London!

While many of the 3 million passengers that the *QE2* had transported shed a tear on hearing of their travelling companion's retirement, others looked to the future with excitement. It is hoped that in retirement *QE2* will be maintained as a maritime icon, to be enjoyed and explored by generations to come.

Thousands compete for a view of *QE2*'s farewell.

AFTERWORD

BY CAPTAIN IAN MCNAUGHT

I t was with some sadness that I had to announce to the passengers and ship's company that the *QE2* had been sold and was to be retired from service in November of 2008.

Since that morning in June of 2007 in the port of Aalesund in Norway, the *QE2* has had a wonderful season, enjoying a triumphant Round Britain Cruise in September 2007 to celebrate forty years since her christening on 20 September 1967 by HM Queen Elizabeth II, and now we are halfway round our Farewell World Cruise, having made a historic rendezvous with *Queen Victoria* in Sydney.

Later this year we have a tandem transatlantic crossing with *Queen Mary 2* and another Round Britain Cruise before we leave Southampton for the last time on 11 November. By that date, this icon of British shipbuilding will have steamed 5.875 million miles and carried 3 million passengers, been visited by all our Royal Family, and hosted many heads of state and numerous celebrities. She has a long and cherished history and is celebrated wherever she sails.

For the last twenty-one years of my career I am very proud to have played a small part in her history, and in my heart, I know we will never see the likes of her again.

Van McNaught

Captain Ian McNaught
Master *QE2*
Farewell World Cruise
9 March 2008

QE2 FACTS

GENERAL INFORMATION (1969–2008)

Name: *Queen Elizabeth 2 (QE2)*

Gross Registered Tonnage (1969): 67,129 tons

Gross Registered Tonnage (2008): 70,327 tons

Passenger Decks: 12

Length: 963ft

Width: 105.25ft

Builders: John Brown Shipyard / Upper Clyde Shipbuilders

Keel Laid: 5 July 1965

Launched: 20 September 1967 by HM Queen Elizabeth II

Maiden Voyage (started): 2 May 1969

Final Voyage (ended): 27 November 2008

Maximum Passenger Capacity: 1,777 persons

Standard Crew Capacity: 1,040 persons

Port of Registry: Southampton, England

Official Number and Signal Letters: 336703 and G.B.T.T. respectively

ENGINE ROOM INFORMATION (1987–2008)

Diesel Engines: 9 x 9 Cylinder MAN B&W diesels

Electric Motors: 2 x 350 tons, one on each propeller shaft

Boilers: 9x exhaust gas. 2x oil-fired

Propellers: 2 five-bladed outward turning variable pitch propellers (VPP)

Output at Propellers: 44 MW each

Bow Thrusters: 2 stone kamewa, 1,000hp each

Stabilizers: 4 Denny Brown

Rudder weight: 75 tons

Forward Anchors: 2 at 12½ tons each

Forward Anchor Cables: 2 at 1,080ft long

Aft Anchor: 1 at 7¼ tons

Aft Anchor Cables: 720ft long

(Courtesy of Pam Massey)

SOME INTERESTING FACTS

Service Speed: 28.5 knots

Top Speed: 32.5 knots

DID YOU KNOW?

The *QE2* was sold to Istithmar for US$100 million.

The *QE2* was the flagship of the British Merchant Navy from her launch until 2004.

The *QE2* has twenty lifeboats and fifty-four liferafts. Their total capacity is 3,821 persons.

The *QE2* was the last ocean liner to be built in the United Kingdom.

The *QE2* made her 1,000th voyage in 1995.

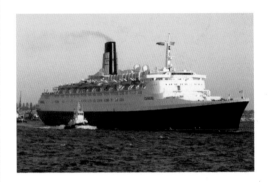

BUILT TO LAST

In 1995 the *QE2* was hit by a rogue wave, caused by Hurricane Luis, whilst crossing the Atlantic Ocean. The wave was estimated at being 95ft (29m) high – the same height as the ship's bridge from the ocean! The incident occurred early in the morning and most passengers slept through the event. There were a few buckled hull plates where the force of the wave hit, but no major damage occurred.

DID YOU KNOW?

QE2 completed ten extended voyages as well as twenty-five world cruises.

GLOSSARY OF NAUTICAL
(AND *QE2*) TERMS

Abeam – Off the side of the ship, at a 90° angle to its length.

Aft – Near or towards the back of the ship.

Amidships – Towards the middle of the ship.

Bow – The forward-most part of a ship.

Bridge – Navigational command centre of the ship.

Colours – The national flag or emblem flown by the ship.

Draft – Depth of water measured from the surface of the water to the ship's keel.

Forward – Near or towards the front of the ship.

Heritage Trail – A self-guided tour aboard the *QE2* which visits objects of historic value.

Hove to – When the ship is at open sea and not moving.

Hull – The body of the vessel that stretches from the keel to the superstructure (*QE2*'s is painted black).

Keel – The 'spine' of the ship, to which the hull frames are attached – the lowest point of a vessel.

Knot – 1 nautical mile per hour (1 nautical mile = 1,852m or 1.15 statute miles).

Leeward – The direction away from the wind.

Pitch – The alternate rise and fall of the ship which may be evident when at sea.

Port – The left side of the ship when facing forward.

Starboard – The right side of the ship when facing forward.

Stern – The rearmost part of a vessel.

Superstructure – The body of the ship above the main deck or hull (*QE2*'s is painted white).

Tender – A small vessel (sometimes a lifeboat) used to transport passengers from ship to shore.

Wake – The trail of disturbed water left behind the ship when it is moving.

Windward – Direction the wind is blowing.

BIBLIOGRAPHY

BOOKS

Bombail, M., Buchanan, G., Cousteau, J., Duffy, J., Hare, S., Verlomme, H., *A Tribute to* QE2 *and the North Atlantic Ocean*, Rouge de Mars, Switzerland, (2000).

Buchanan, G., Queen Elizabeth 2*, Sailing into the New Millennium*, Past and Present Publishing, UK, (1996).

Hutchings, D., QE2 – *A Ship for all Seasons*, Waterfront, UK, (2002).

Miller, W.H. and Correia, L.M., *RMS* Queen Elizabeth 2 *of 1969*, Liner Books, Portugal, (1999).

Miller, W.H., *Pictorial Encyclopedia of Ocean Liners, 1860 to 1994*, Constable and Company, UK, (1995).

Ward, D., *Berlitz 2006 Complete Guide to Cruising & Cruise Ships*, Berlitz, UK, (2007).

Warwick, R.W., QE2 – *The Cunard Line Flagship, Queen Elizabeth II*, Norton, UK, (1999).

WEBSITES

Chris Frame's Cunard page: www.chriscunard.com

The QE2 Story Forum: www.theqe2story.com/forum

OTHER SOURCES

Cunard, QE2 *Golden Route World Cruise Brochure*, Cunard Australia, Sydney, (1994).

Cunard, QE2 *the Queen of the Seas* (VHS), Ocean Books / Scott Riseman Lipsey Meade, (1993).

Cunard, QE2: *The Legend Continues* (VHS), Ocean Books / Scott Lynds, (1995).

PERSONAL CONVERSATIONS

Commodore R.W. Warwick

Captain I. McNaught

Michael Gallagher

Commodore C. Rynd

Chief Engineer P. Yeoman

QE2 sails into the sunset. (Courtesy of Alex Lucas)

If you are interested in purchasing other books published by The History Press
or in case you have difficulty finding any of our books in your local bookshop,
you can also place orders directly through our website

www.thehistorypress.co.uk